GUITAR BASICS

A Beginning Guitar Method

Book 1

Michael Christiansen

KENDALL/HUNT PUBLISHING COMPANY
4050 Westmark Drive Dubuque, Iowa 52002

Photos by: R.T. Clark, Doug James

Illustrations by: Barbara Edwards, Glen Edwards, Nataunya Kay

Contents

Preface

This book is a beginning method for group or individual instruction which presents many ways the guitar may be used to accompany singing or another instrument and presents the elements used to play single note melodies on the guitar. Though the book was written for the recreational guitarist, the intent is for the serious student to develop good technique and understand the basics well enough to continue studying the guitar.

This book contains chapters on *basic chords, accompaniment styles* (including strumming and fingerpicking), and how to play *single note melodies* using standard notation. It is arranged in sequence so each concept is a "follow-up" of a previously learned skill. If the text is used for group instruction, the student may progress at his or her own rate of speed. The student should feel comfortable playing one accompaniment style or group of notes before trying the next.

In many music books and sheet music the guitarist is provided with the chords, but there is no indication of how the song is to be strummed or picked. This book provides many popular accompaniment patterns which can be used to play not only the traditional songs contained in the book, but also songs from music books and sheet music. You may wish to use a popular song book for supplemental music. When an accompaniment pattern is presented, the student can practice songs from the song book as well as the suggested songs.

I would like to thank Dr. Max F. Dalby for his assistance and a special thank you to my wife Kathy for her patience and encouragement.

To the best of my knowledge, the songs and exercises in *Guitar Basics* are either original or Public Domain (non-copyright). Any arrangement which is identical to another arrangement of the same piece is purely coincidental.

M. C.

1

FUNDAMENTALS

DEFINITION OF TERMS

Up the Neck. Toward the body.

Down the Neck. Away from the body.

Plectrum. The small instrument made of nylon or plastic which is held between the thumb and first finger and is used to strike the strings. It is also referred to as a 'pick.'

Pick. a. The act of stroking the string to produce a sound. b. Another name for the plectrum.

Open. No fingers of the left hand pushing on the strings while the right hand is stroking the strings or string.

Chord. More than two notes sounded at the same time.

Strum. Stroking more than two strings at the same time so the strings vibrate simultaneously.

Lower Strings. The larger strings on the guitar.

Higher Strings. The smaller strings on the guitar.

1st String. The smallest string on the guitar.

6th String. The largest string on the guitar.

Acoustic Guitar. Any non-electric guitar.

Electric Guitar. A guitar which has magnetic 'pick-ups' which convert the vibration of the strings into a current. This current is then passed through a chord to an amplifier.

Amp or Amplifier. The device which electrically amplifies an electric guitar.

Meter. The number of beats or counts per measure.

Tempo. The speed of counts per measure.

6-String Chord. A chord which may have all 6 strings strummed or picked.

5-String Chord. A chord which may have 5 strings (all but the 6th string) played.

4-String Chord. A chord which may have 4 strings (all but the 6th and 5th strings) played.

Accompaniment Pattern. A series of strums or a series of strings picked in a specific pattern. Each pattern takes one measure to complete and is repeated every measure.

Strum Pattern. A series of down and up strums combined to form a rhythmic pattern.

Fingerstyle. Using the fingers of the right hand to stroke the strings rather than using a pick.

PARTS OF THE GUITAR

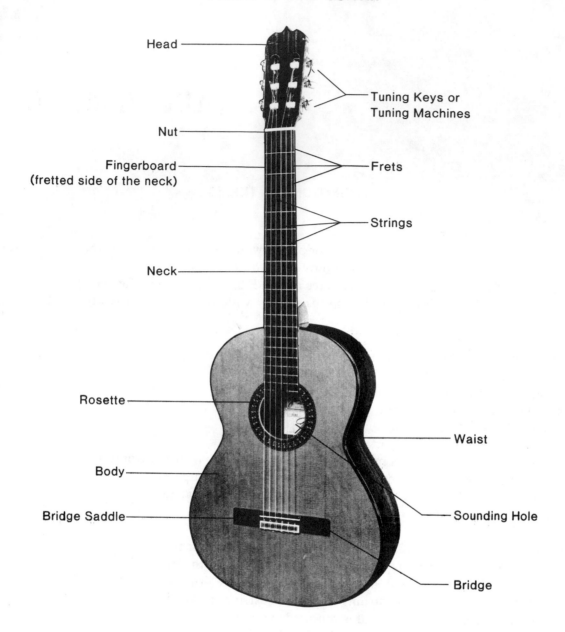

Head

Tuning Keys or
Tuning Machines

Nut

Fingerboard
(fretted side of the neck)

Frets

Strings

Neck

Rosette

Waist

Body

Sounding Hole

Bridge Saddle

Bridge

FINGER NAMES

Finger Numbers

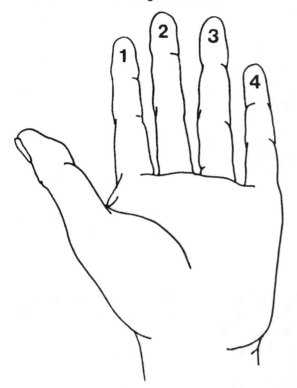

Left Hand

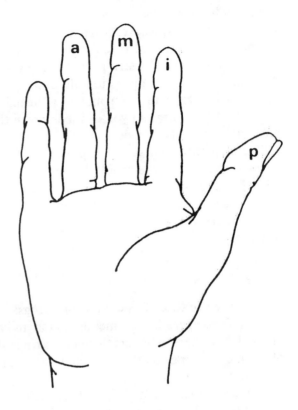

Right Hand

Right Hand

p = **pulgar** (thumb)
i = **indice** (index finger)
m = **media** (middle finger)
a = **anular** (third finger)

BUYING A GUITAR

A reliable music store should carry a wide selection of guitars from which you could choose. Ask your teacher which brands he would suggest. You might also ask him to help select a guitar for you. You do not need an expensive instrument in the beginning. Choose a guitar which feels comfortable to you. Do not choose one that is too large for you to hold correctly.

Strum across the strings and make sure they do not buzz. If the action (distance between the fingerboard and the string) is too high, the strings will be hard to push down. If the action is too low, the strings will buzz. The action may be adjusted, but the guitar should play fairly easily when it is purchased.

Hold the guitar so you can look down the neck from the head of the guitar. Make sure the neck is straight, not warped or bowed.

Buy a case that suits the price of your guitar. Do not buy a case that costs more than the guitar. The case you purchase should be able to protect your guitar from damage.

The type of guitar you buy should be influenced by the style of music you wish to play. Classical guitarists use classic guitars. Jazz and "Rock" guitarists use electric guitars. Folk singers use 12-string, folk, and classic guitars, etc. However, any style music can be played to a certain level of proficiency on any type guitar.

STRINGS

There are three basic kinds of strings: nylon strings, flat-wound strings, and round-wound strings.

Nylon strings have a mellow sound and are best suited for the classic guitar. They can also be used on the folk guitars, whereas the metal strings should never be used on a classic guitar because the pressure of the metal strings on the neck could warp the neck. The nylon strings feel softer when pushing on them than do the metal strings.

Flat-wound strings have a narrow flat piece of metal wrapped around a metal core. These strings should be used only on the electric guitar. These strings feel smooth and will not have a scratching sound when your fingers slide on the string. It is a "dead" sounding string made of metal and should never be used on acoustic guitars. They do not resonate enough to produce a good tone on an acoustic guitar.

Round-wound strings have a round wire wrapped around a metal core. These strings sound louder and ring longer. They should be used on the folk and arch top guitars. Some round-wound strings may be used on electric as well as acoustic guitars. The bronze round-wound strings which are metal are a louder sounding string. They may not be used on an electric guitar. They are not treated magnetically and cannot be heard through the amplifier.

All types of strings come in various gauges of diameter. The heavier the gauge, the thicker the string. The beginning student should use medium or light gauges. The extra-light gauge is hard to keep in tune, but is preferred by rock guitarists because they are easy to bend. The heavy gauge is harder to push down but stays in tune longer.

CARE OF THE GUITAR

When caring for the guitar, there are several things to remember:

1. Be careful not to expose your guitar to rapid temperature or humidity changes. This could crack the wood or finish of the guitar. In a dry climate a guitar humidifier could be used to keep the wood of the guitar from drying and cracking.
2. Do not leave your guitar by a heater vent, open window, air conditioning unit, or in a car when the weather is very cold or very hot.
3. Wax the guitar. This helps protect the finish and wood of the instrument. Most music dealers carry special guitar polishes. If you do not have guitar polish, a good furniture polish will do.
4. Loosen the strings on your guitar if it is being shipped or taken on an airplane.

HOLDING POSITION

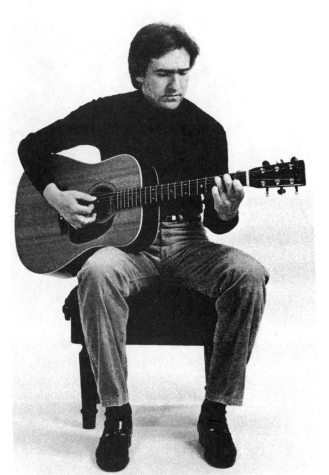

This is the position we will use.

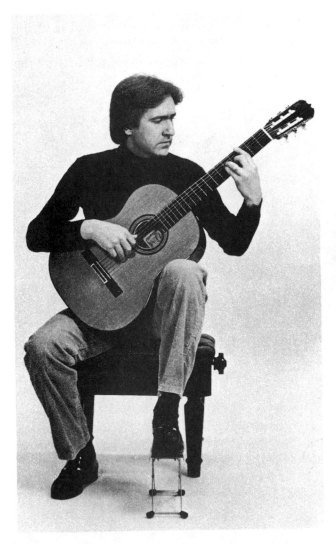

The guitar should be held so it feels comfortable to you. The sitting position is the best and the most comfortable position for the beginning student. Both feet should be on the floor and the waist of the guitar should rest on the right leg. The neck of the guitar should extend to the left. The body of the guitar should be tilted slightly toward your body. Be careful not to let the neck of the guitar tilt downward. The right arm should come around the body of the guitar so the right hand is placed over the sounding hole. This is the standard folk sitting position. It is the position which should be used when playing the music in this book.

The classic guitarist uses a different sitting position. The waist of the guitar rests upon the *left* leg and the neck is held higher than in the folk sitting position. The left foot is elevated. The classic holding position is different from the folk sitting position in other ways, but because this is not a classic guitar method they will not be discussed.

LEFT HAND POSITION

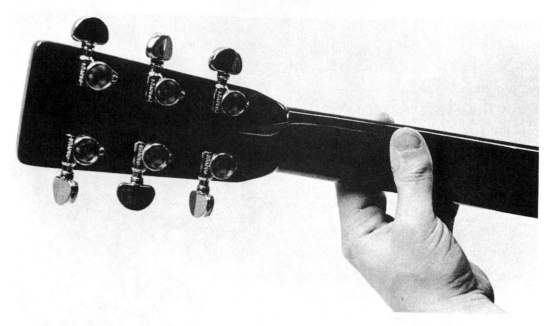

The left hand should be placed on the neck of the guitar with the thumb up against the back of the neck. The thumb should be placed between the 1st and 2nd fingers on the opposite side of the neck. The thumb should never be help parallel to the neck. Be careful not to bend the thumb or wrap it around the neck of the guitar. The palm of the hand should not touch the neck.

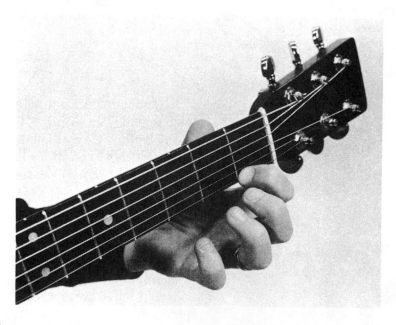

The tips of the fingers should be used when pushing on the strings. Bend the fingers so the knuckles form a square. Place the 1st finger over the string next to the fret. The fingers should never be placed on top of the fret. Placing the finger on top of the fret deadens the sound. Placing the finger too low in the fret will cause the string to buzz.

RIGHT HAND POSITION

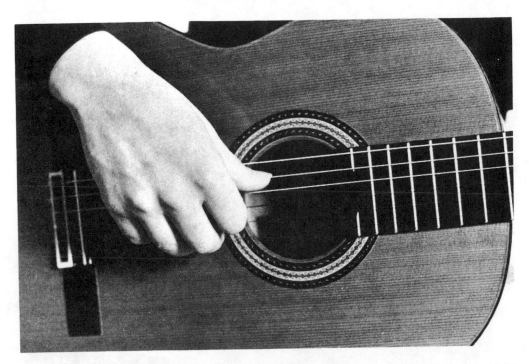

The right hand should be placed over the sounding hole of the guitar. The wrist should have a slight bend in it so the fingers are slightly behind the thumb when they are touching the strings. The second and third fingers of the right hand should be relaxed and should be bent, but not into a fist-like position.

Top View

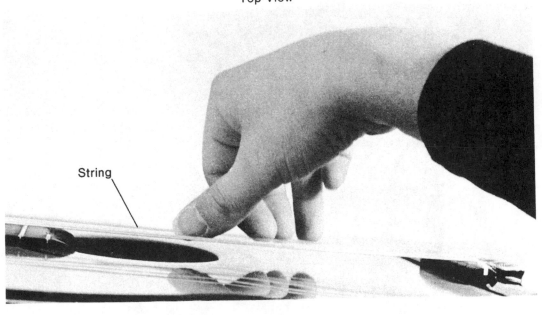

Pick the first string open (open means there will be no fingers on the left hand pushing on any of the strings). With the thumb, pick the first string down (pick means the action of stroking a string). Now, pick the second string open and then the third string open. Repeat this action on all six strings.

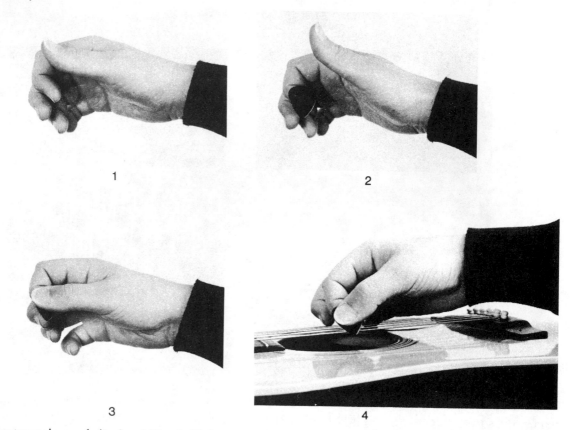

1 2 3 4

If the plectrum is used, it should be held between the thumb and first finger so its point is aimed towards the strings. The 1st finger should be bent. The 2nd and 3rd and 4th fingers are slightly bent. The 4th finger should be bent and may rest on the pickguard. Be careful not to hold the pick too tightly.

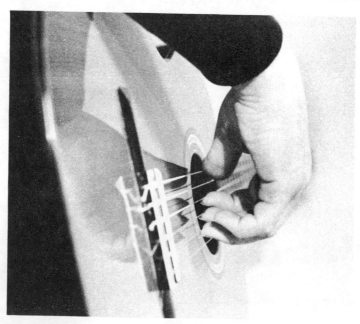

When "fingerpicking," a combination of the tips of the fingers and the nails should be used. Do not stroke the string with just the nails. When stroking, the tip of the finger should strike the string first, then the tip of the nail should strike the string. These actions should be so rapid that it sounds as if they are striking the string at the same time. The fingers should strike the string straight up, not across the string.

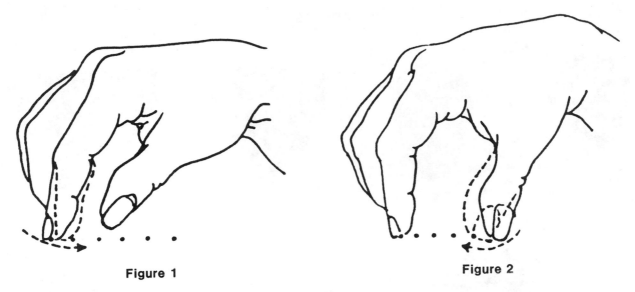

Figure 1 **Figure 2**

REST STROKE

The rest stroke is commonly used to play melodies and is popular in solo guitar playing. To do the rest stroke, the flesh on the tip of the finger strokes the string in an upward (not outward) motion. The nail strokes the string as it passes by. The finger then comes to rest on the next string (see fig. 1).

The thumb rest stroke is done by moving the thumb downward and playing the string with the tip of the thumb and the nail. The thumb then comes to rest on the next string down (see fig. 2).

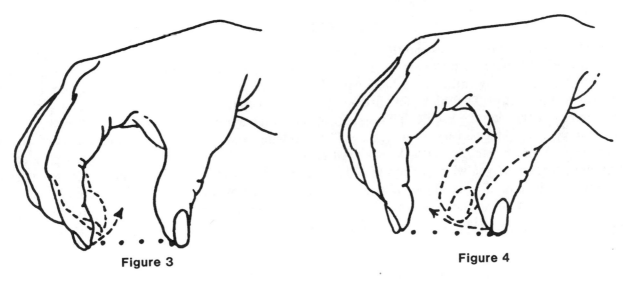

Figure 3 **Figure 4**

FREE STROKE

This is the stroke which is commonly used in accompaniment style guitar playing. Because it allows the string to ring, it is good for fingerpicking. It may also be used to play single note melodies. To do the free stroke, the finger picks the string and then is pulled out slightly to avoid touching the next string. Remember, it barely misses the next string. Do not pull away from the guitar too far or the string will slap (see fig. 3).

The free stroke with the thumb is similar. After the thumb strokes the string, it is moved slightly outward to avoid hitting the next string (see fig. 4).

PLECTRUMS (Picks)

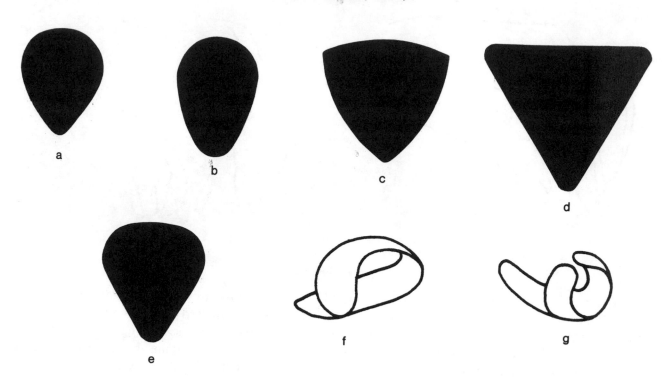

PLECTRUMS (Picks)

Picks come in many shapes and thicknesses. It is suggested that beginning students use the medium size and medium thickness pick (fig. e). Large and thick picks are hard to control. They seem to grab when stroking the string rather than bend with the stroke. The smaller and larger picks (fig. a, fig. d) are also hard to control. The thick picks are becoming more popular because you can not only pick softly with them, but they can be used to pick harder and produce more volume than the thin picks. Finger and thumb picks produce a very brilliant tone. The beginning student will find them hard to control. The thumb (fig. f) and finger (fig. g) picks are used primarily in folk music and are not recommended for beginning students. If you wish to fingerpick, let your fingernails on your right hand grow about 1/16 of an inch past the end of your finger. Use a combination of the skin on the tip of your finger and your fingernail to stroke the string. The tip of the finger strikes the string first and is quickly followed by the fingernail striking the string. This action takes place so rapidly it should sound as if the string is struck once.

Fingernails

The fingernails on your left hand should be kept short. The nails of your right hand should grow to 1/16 of an inch past the end of your finger. If your nails are soft or continually breaking, you can use fingernail hardener on them. The nails of the right hand should not be jagged, but filed smoothly and rounded slightly.

WALKING THE BOARD

Try an exercise called "walking the board." Pick the first string open, then, pick the first string while the first finger of the left hand is in the first fret; next, pick the first string while the second finger of the left hand is in the second fret (It is not necessary to keep the 1st finger down); pick the first string while the third finger of the left hand is in the third fret; and finally, pick the first string while the fourth finger of the left hand is in the fourth fret. Repeat this exercise in reverse. Now, repeat this exercise on strings two and three. Make sure your fingers on the left hand are against the fret so you do not get a buzzing or "fretting out" sound. Also, be careful not to place the fingers of your left hand on top of the fret. While doing this exercise be sure your thumb remains positioned up and down on the back of the neck of the guitar.

When picking the strings on the guitar, you should not stroke the strings away from the guitar or into the hole of the guitar. The picking action should be a combination of the thumb, the plectrum (if used), the wrist, the elbow, and the whole arm.

If clear tones do not result when picking the strings, several things could be wrong:

1. You may not be pushing hard enough on the strings.
2. Your finger may not be against the fret correctly.
3. Something may be wrong with the guitar.
 a. The bridge may need adjusting.
 b. The neck may be warped.
 c. The nut may be set too low.

2

TUNING THE GUITAR

There are several ways to tune the guitar. One of the simplest and most effective ways is to tune the guitar to itself. By that, I mean, if you have a piano or a pitch pipe, tune the first string of the guitar to E above middle C (see fig. 2). Then put a finger in the **FIFTH FRET** on the **SECOND STRING** and pick the second and the first strings together; they should sound the same (fig. 1). If they do not, adjust the string which has a finger on it until the two strings match in pitch.

When the second string is in tune place a finger in the **FOURTH FRET** on the **THIRD STRING**. Pick the third and the second strings together. If they do not sound the same, adjust the third string which is the string with a finger on it. When these two strings sound the same match the fourth string to the third by placing a finger in the **FIFTH FRET** on the **FOURTH STRING** and match it to the third string open. The process is then repeated in the **FIFTH FRET** on the **FIFTH STRING** and matching it to the fourth string. Put a finger on the **SIXTH STRING** on the **FIFTH FRET** and match it to the fifth string open (see fig. 3).

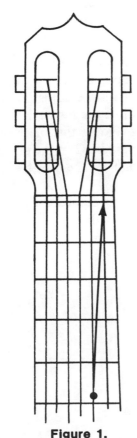

Figure 1.

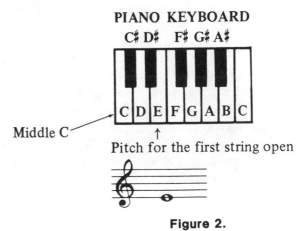

Middle C

Pitch for the first string open

Figure 2.

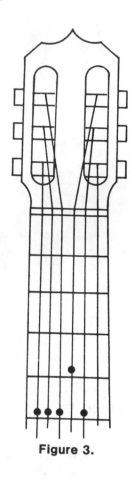

Figure 3.

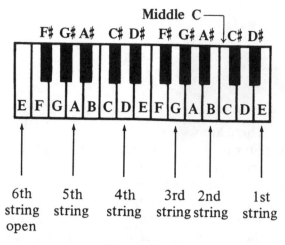

Figure 4.

After all of this is done, strum several chords and see if the chords sound in tune. If they don't sound quite right, repeat the process and if it still does not help something may be wrong with the instrument itself. The frets may be misplaced or the bridge of the guitar may need some adjusting. If so take the instrument to a qualified repairman or to an instructor and let him adjust the instrument.

You may also tune each string on the guitar to pitches on the piano. If this method is used then tune the first string open (without any fingers on the string) to E above middle C on the piano. The second string is tuned to B just below middle C. The third string to G below that B. The fourth string to D. The fifth string to A and the sixth string is tuned to E (see fig. 4).

The guitar may also be tuned to a tuning fork. E tuning forks may be purchased. Tap the tuning fork and touch it on the bridge of the guitar. The sound which resonates will be the pitch you match to the first string.

3

STRUMMING CHORDS

One of the most popular varieties of guitar playing is to strum chords. Strumming chords can be used to accompany singing or to accompany another instrument. Chords (on the guitar) can be defined as three or more strings strummed at the same time.

Strum all six strings (open) down with the right thumb. Be sure to do this quickly so the strings are heard together. **DO NOT** strum with an outward stroke. Pull the thumb straight down across the strings. When using a pick, the same downward motion is used. The strum should be a combination of the movements of the wrist, elbow, and thumb.

Figure 5. The following is a chord diagram. It is a drawing of the guitar neck. The horizontal lines represent the frets. The vertical lines represent the strings.

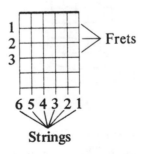

Figure 6. In the diagram below, the dots indicate where to place the fingers. The curved line underneath the diagram shows how many of the strings should be strummed. (In figure 6, 4 strings may be strummed.) All of the strings may not be played on many of the chords. The numbers indicate the left-hand finger(s) to be used to depress the string(s).

Here are some basic chords. Learn these chords first: simple G, simple C, simple Em, simple G7, and D. Then learn: G, C, Em, G7, A7, and D7. Finally, learn all of these chords.

BASIC CHORDS

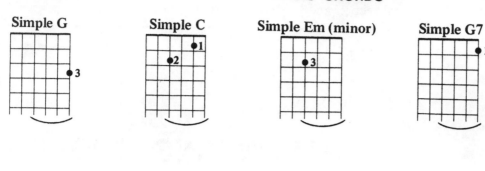

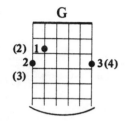 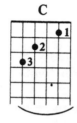 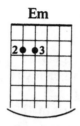 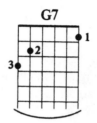 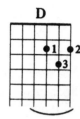

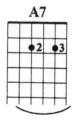 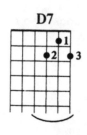 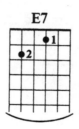 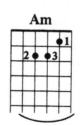 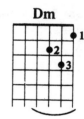

*(2)(3)(4) Alternate fingering for the G chord.

These two marks are called strum bars. They both indicate that a chord is to be strummed one time, down. One strum bar gets one beat. They may be used interchangeably.

Practice the following exercises. Try not to pause between the chord changes. To help eliminate pauses between chord changes, keep strumming with the right hand even if the left hand fingers are not in place yet. You may use the simple versions of the chords first; then try using the more difficult versions.

RHYTHM SHEETS

The following pieces are called *rhythm sheets*. A rhythm sheet is a song which has only the lyrics and the chords written above them. At the left of the song appears the time signature (3/4, 4/4, etc.). The top number of the time signature indicates how many times each chord name is to be strummed. If it is in 3/4, each chord is to be strummed down three times. If a chord name appears twice in a row, the strum pattern (four strums for 4/4, three strums for 3/4) is to be repeated.

Here are four examples of rhythm sheets. Practice strumming the chords in the manner explained above to the following:

Down in the Valley

C /// C C C G7 G7 G7

$\frac{3}{4}$
1. Down in the valley valley so low. Hang your head
2. Build me a castle forty feet high. So I can
3. Write me a letter send it by mail. Send it in

G7 G7 G7 C C
o—ver hear the wind blow.
see him as he rides by.
care of Birming-ham jail.

He's Got the Whole World in His Hands

D //// D D

$\frac{4}{4}$
1. He's got the whole world in His hands. He's got the
2. He's got the little bitty baby, etc.
3. He's got you and me brother, etc.

A7 A7 D
whole world in his hands, He's got the whole world

D A7 D
in His hands, He's got the whole world in His hands. He's got—

Home on the Range

 G G C C
$\frac{3}{4}$ Oh give me a home where the buffalo roam,
 G A7 D7
Where the deer and the antelope play,
D7 G G7 C C
Where seldom is heard, a discouraging word
 G D7 G G
And the skies are not cloudy all day.
G D7 G
Home, Home on the range
G G A7 D7
Where the deer and the antelope play,
D7 G G7 C C
Where seldom is heard a discouraging word,
 G D7 G
And the skies are not cloudy all day.

My Bonnie

$\frac{3}{4}$

```
     G          C        G
My bonnie lies over the ocean,
G   G       A7       D
My bonnie lies over the sea
D   G         C        G
My bonnie lies over the ocean
G   A7         D7        G   G
Oh bring back my bonnie to me.
G     G    C    A7
Bring back, bring, back,
     D7           D7      G    G
Oh bring back my bonnie to me, to me.
G     G    C    A7
Bring back, bring back,
     D7           D7        G    G
Oh bring back my bonnie to me.
```

Try to eliminate the pause which often occurs between chord changes. Also practice singing while you strum. Practice the chord changes even if the melody is not familiar to you.

MEASURED MUSIC

When playing chords on the guitar, the guitarist is interested in the meter (number of counts or beats per measure) of the song, and which chord is to be played in each measure. A measure is the distance between the vertical black lines on the staff (a staff consists of the five horizontal lines).

=MEASURE= | =MEASURE= | =MEASURE=

The number of beats per measure is indicated by the time signature (the numbers at the beginning of the piece). Beats are divisions of time in music. The top number shows how many beats are in a measure, the bottom number indicates what kind of note gets one beat.

In this example, there are four beats per measure.

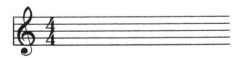

In this example, there are three beats per measure.

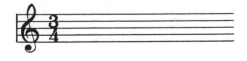

(if C or ₵ appears at the beginning of the music in place of the time signature, for the purposes of this book it means the piece is in 4/4 meter).

When playing chords, do not be concerned with the notes. Such as: 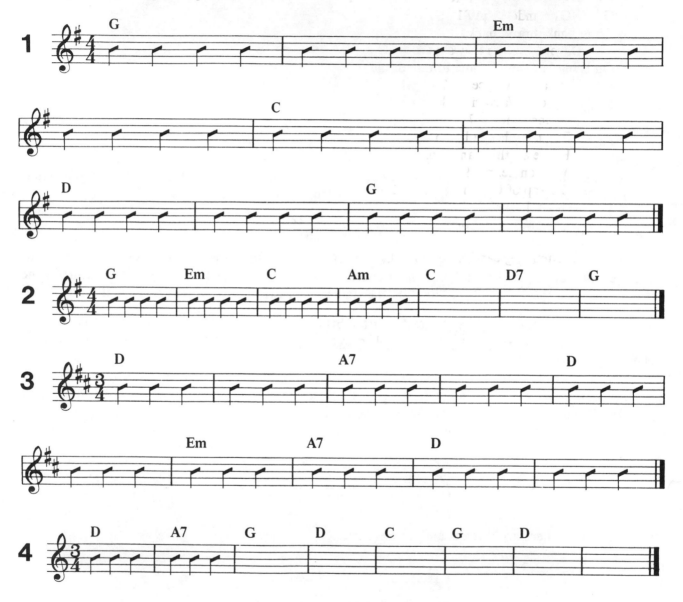. In the exercises
in this book, the notes are missing, but they are written in the songs found in the Song Section of the
book.

If you are playing the chords to a song in 4/4 meter, you should strum down four times in each
measure. If the song is in 3/4 meter, you should strum three times down in each measure. The chords
to be strummed are written above the measures. If no chord appears above a measure, repeat strumming
the chord of the preceding measure.

Try the following examples:

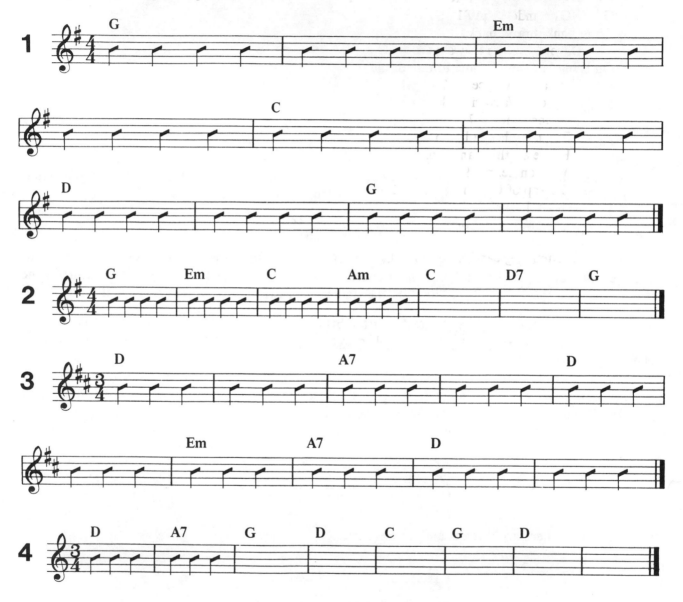

Try the following songs from the song section strumming four times per measure in 4/4 and three times for 3/4. If you do not know a chord in a song or example, find it on the Chord Reference Sheets, p. 87 in the back of the book.

4/4
He's Got the Whole World, p. 71
Jingle Bells, p. 76
John Henry, p. 85
Michael Row the Boat Ashore, p. 68
Oh, Sinner Man, p. 82
She'll Be Comin' Round the Mountain, p. 70
Shenandoah, p. 81
This Train, p. 68
Worried Man Blues, p. 69

3/4
Amazing Grace, p. 71
A Poor Wayfaring Stranger, p. 80
Clementine, p. 73
Down in the Valley, p. 74
Home on the Range, p. 84
My Bonnie, p. 79
On Top of Old Smokie, p. 73
Silent Night, p. 67
When Johnny Comes Marching Home, p. 66

This type of strumming can become boring, so other "strum patterns" can be used.

STRUM PATTERNS

When two strum bars are connected with a beam (), two strums are played in one beat. The first strum is counted as the number of the beat in the measure on which it comes. Such as 1, 2, 3, etc. The second strum is counted as 'and.'

1 2 & 3 4 &

The signs above the strum bars indicate the direction of the strum. This sign: ⊓ means strum down. This sign: ∨ means strum up.

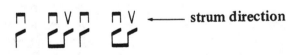
strum direction

The strumming may be down with a pick, the thumb, or the first finger. See p. 8 for the explanation of how to hold a pick. When strumming up, only two or three strings are strummed. The up strum is done with an upward and outward motion. In this book, when two strums are connected by a beam, the first strum is played down and the second is strummed up.

When tapping your foot to keep the beat, the down strum is played when your foot is down and the up strum played when the foot is up.

Practice the following to get the feel of strumming down up.

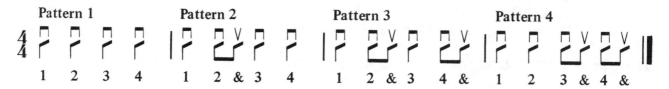

The following strum patterns are grouped according to meter. The ones at the top will work to play songs in 4/4 meter and the ones at the bottom may be used to play songs in 3/4. They will provide interesting accompaniments for many pieces. The strum patterns are listed in order of difficulty. Each pattern takes one measure of music to complete. Once a pattern has been selected to play a song, the same pattern should be used in every measure. Holding a G chord, practice each strum pattern. Master one strum pattern before moving on to the next.

Patterns for 4/4 meter: (note that each strum pattern takes one measure to complete)

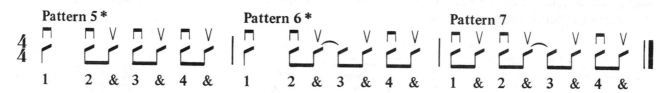

⌒ This is a tie. When it connects two strum patterns, the first strum is held through the time value of the second strum.

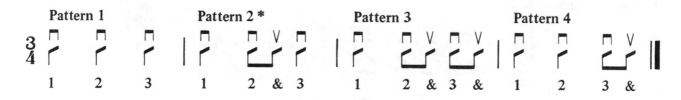

Patterns for 3/4 meter:

*These are the most commonly used strum patterns.

The examples below use strum patterns for 4/4 and 3/4 meter. Practice each exercise using strum pattern number 1, then 2, 3, and so on. Remember each pattern takes one measure to complete. For now, do not use different strum patterns in different measures of the same piece.

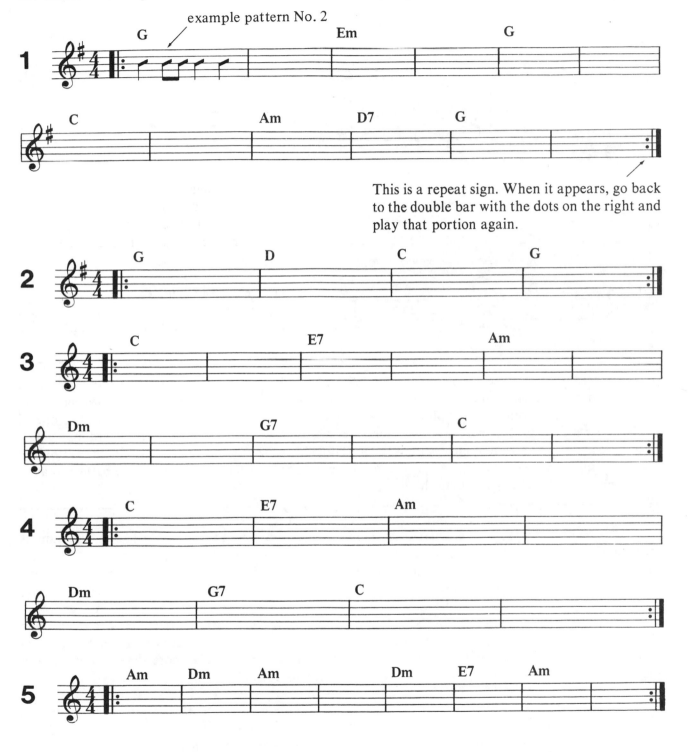

This is a repeat sign. When it appears, go back to the double bar with the dots on the right and play that portion again.

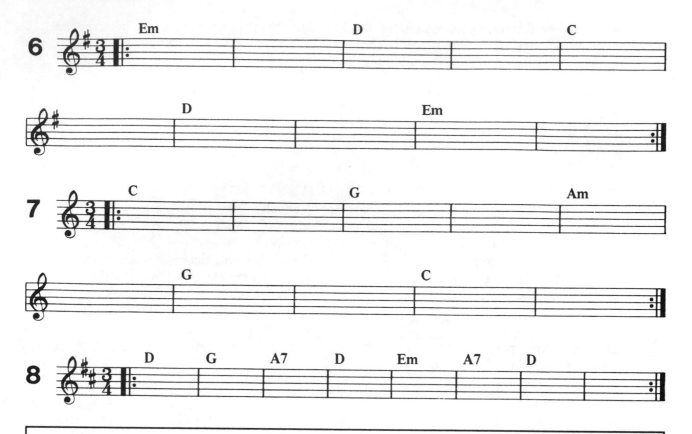

Note: With all the examples of the book you may wish to repeat each measure for the sake of extended practice on strum or pick patterns without having frequent chord changes. However, the examples should eventually be played as written. Some of the 'practice examples' will have one chord per measure, some will have two chords per measure, and in some examples a chord may get two measures. If a strum or pick pattern is not written in or above an example, you should continue the strum pattern being used. In the case of alternating bass or fingerpicking, do the pattern that is appropriate for that particular chord.

The strum patterns for 4/4 meter may be used to play *any* song that is in 4/4 meter. The same is true for the 3/4 strum patterns and songs that are in 3/4 meter. The music will not have the strum patterns written out. The correct strum pattern should be determined by the meter of the song. When you know the meter of the song, the strum pattern used is up to you. Once a strum pattern has been selected, the same pattern should be used in every measure of the song. (Select patterns on page 22).

Try the following songs from the Song Section of this book using strum patterns for 4/4 meter. You should play the songs using simple patterns first. Then try the more complicated patterns. Songs from other books or sheet music may also be practiced as long as they have no more than one chord in a measure (two or more chords in a measure will be dealt with later).

This Train, p. 68
She'll Be Comin' Round the Mountain, p. 70
Worried Man Blues, p. 69
He's Got the Whole World, p. 71
Michael Row the Boat Ashore, p. 68

Jingle Bells, p. 76
Shenandoah, p. 81
On, Sinner Man, p. 82
John Henry, p. 85

Try the following songs from the Song Section (or other music* in 3/4 meter having only one chord per measure) using strum patterns for 3/4 meter.

When Johnny Comes Marching Home, p. 66
Down in the Valley, p. 74
Silent Night, p. 67
My Bonnie, p. 79
Amazing Grace, p. 71

Clementine, p. 73
A Poor Wayfaring Stranger, p. 80
On Top of Old Smokie, p. 73
Home on the Range, p. 84

> **Note:** All of the pieces listed from the Song Section should be practiced with the simple strum patterns first. If the book is used for group instruction, all of the students should play the same strum pattern with the song. Then they may use whichever strum pattern they are capable of doing. This allows each student to progress at his own rate of speed. The students may play the same song in class using different strum patterns as long as the patterns fit the correct meter.

TWO CHORDS IN A MEASURE

When two chords appear in one measure, the counts must be divided. In 4/4 meter, if there are two chords per measure, strum each chord down two times. In 3/4 meter, find which chord gets the majority of the measure and strum that chord 2 times and the other one down once. If there is one chord in the measure, use one of the strum patterns from p. 22. Practice the following examples:

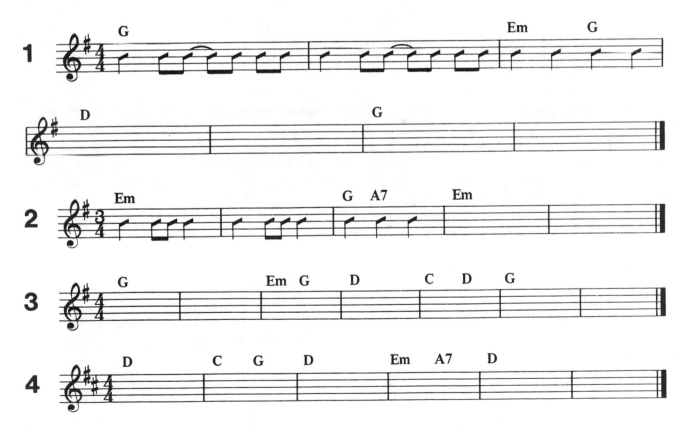

*Other music refers to music not contained in this book, such as sheet music or popular music books. The "other music" may have one or more chords per measure unless music which has no more than one chord per measure is recommended.

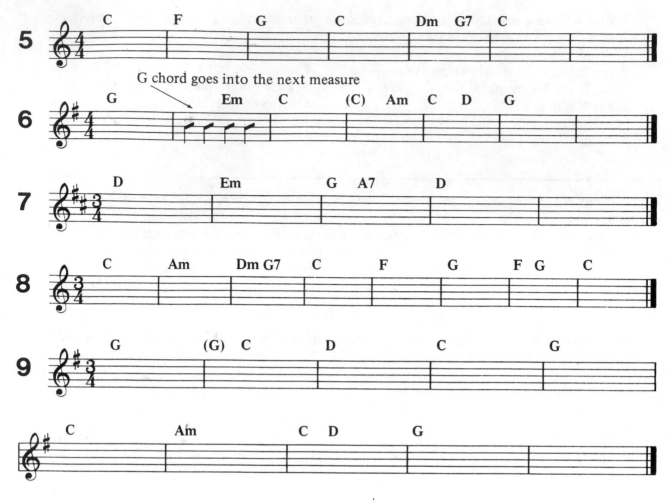

G chord goes into the next measure

Remember, you are not concerned with the notes (♩) on the music, only the chords and the measures.

If more than two chords appear in a measure, play only the first and third chords. Eliminate the others. This rule will apply to all forms of accompaniment (picking as well as strumming). Another type of accompaniment which is usually heard in folk music, but will also apply to other styles, is the *alternating pick-strum* or *alternating bass*.

Practice the following from the song section (or other music in 4/4 or 3/4 which has two chords per measure) using the strum patterns for 4/4 and 3/4 (see p. 22 for the proper strum patterns):

Midnight Special Blues, p. 72
Tom Dooley, p. 74
When the Saints, p. 72
Red River Valley, p. 77
Oh, Suzanna, p. 78
Aura Lee, p. 77

Kum Ba Yah, p. 78
Cripple Creek, p. 83
Streets of Laredo, p. 70
It Came Upon a Midnight Clear, p. 75
Scarborough Fair, p. 86

Listed below are other ways in which two chords in a measure may be strummed. Strum the first chord ⊓ ⊓ and the second chord ⊓ V ⊓

G Em
⊓ ⊓ ⊓ V ⊓

Strum the first chord ⊓ ⊓ V and the second chord ⊓ ⊓ V

G Em

Strum the first chord ⊓ ⊓ V and the second chord ⊓ V ⊓ V

G Em

This pattern ⊓ ⊓ V ‿ V ⊓ V may also be divided when playing two chords in a measure. The second chord is played on the first up strum.

Like this:

In 3/4 time, the first chord may be strummed ⊓ and the second chord strummed ⊓ V ⊓

G Em

Practice the following exercises using these other patterns.

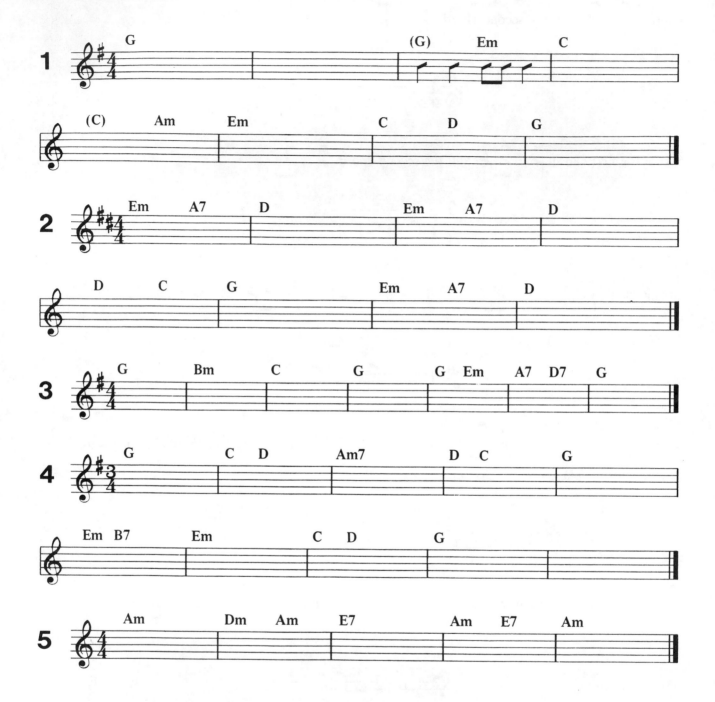

4

ALTERNATING BASS

ALTERNATING BASS 4/4 METER

Perhaps you have noticed by now that there are 3 basic categories of chords according to how many strings may be strummed. These categories are: 6-string chords, in which all 6 strings may be played (for example, G and Em); 5-string chords in which all but the largest string may be played (for example, C and Am); and 4-string chords in which 4 strings (1, 2, 3, and 4) are played (for example, D and F). These categories are important in that the alternating bass and fingerpicking patterns will be presented by referring to the chords as 6, 5, or 4-string types.

In playing one measure of a 6-string chord in 4/4 meter using the alternating bass type of accompaniment, one would pick the 6th string (single string) and then strum the chord one time followed by picking the 5th string and strumming the chord again. The picking of a single string gets one count or beat and the strum gets one beat. The pattern looks like this:

The pattern (pick-strum, pick-strum) takes one measure or 4 beats to complete. In playing one measure (4/4 meter) of a 5-string chord the pattern is:

The pattern for one measure of a 4-string chord is played as follows:

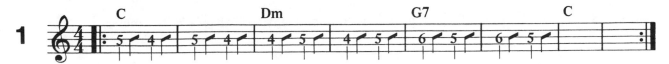

This is the alternating bass type of accompaniment.

Try the following exercise, and remember that the numbers indicate the single strings to be picked:

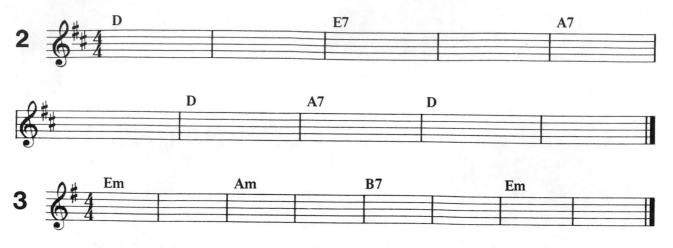

Five-string chords (such as C) may also be played 5 ⌐ 6 ⌐. If the C chord is being played, after 5 ⌐, move the 3rd finger of the left hand to the 6th string 3rd fret to play the 6 ⌐. Then, move it back to the 5th string to play the 5 ⌐.

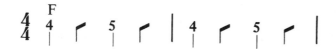

On the four string F chord, after playing the 4 ⌐, move the left hand 3rd finger to the 5th string 3rd fret to play 5 ⌐.

Practice the following using this variation.

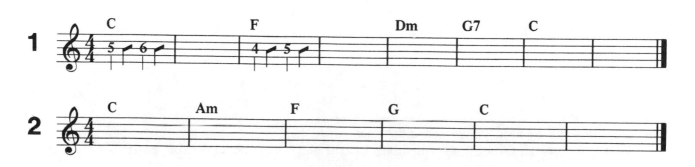

The alternating bass patterns for 4/4 may be used to play any song that is in 4/4 meter.

Try the following songs in the Song Section (or other music in 4/4 having no more than one chord per measure) using the Alternating Bass patterns:

This Train, p. 68
Worried Man Blues, p. 69
Michael, Row the Boat Ashore, p. 68
He's Got the Whole World, p. 71
She'll Be Comin' Round the Mountain, p. 70

Jingle Bells, p. 76
Oh, Sinner Man, p. 82
John Henry, p. 85

Note: Remember, sheet music and the songs in this book will seldom have the accompaniment patterns written out. The accompaniment patterns in this book should be memorized and applied to any song as long as the meter for the accompaniment pattern and the meter for the song are the same.

The Alternating Bass pattern may be divided when two chords are in a measure. To do this, play the first half of each chord's alternating pattern such as:

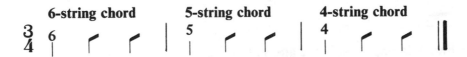

ALTERNATING BASS 3/4 METER

To play the Alternating Bass method for 3/4 meter, the lowest string of the chord is picked followed by two strums. This completes one measure. Each pattern takes three beats to complete. The patterns are as follows:

6-string chord 5-string chord 4-string chord

Try the following examples: (Fill in the patterns on the second example, the one beginning with D). Remember the alternating bass patterns for 3/4 may be used to play *any* song that is in 3/4 meter.

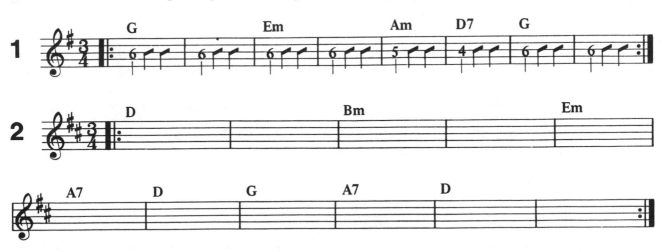

Practice the following songs from the song section using the Alternating Bass for 3/4.

When Johnny Comes Marching Home, p. 66

Down in the Valley, p. 74

Silent Night, p. 67

My Bonnie, p. 79

Amazing Grace, p. 71

Clementine, p. 73

A Poor Wayfaring Stranger, p. 80

On Top of Old Smokie, p. 73

Home on the Range, p. 84

If the same chord is played for more than one measure, the string to be picked at the beginning of the measure may alternate in a similar manner as the 4/4 alternating bass.

Practice the following using this variation.

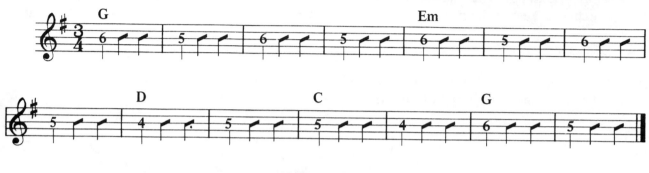

VARIATIONS

A variation on the alternating bass for 4/4 meter would involve substituting 'down-up' strums for the single down strum. The following shows this variation:

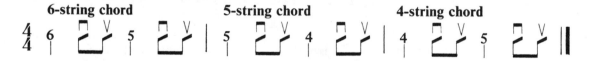

Try the following example using the alternating bass variation:

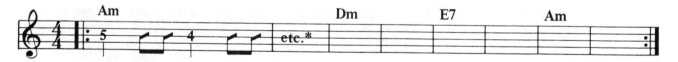

The variation on the Alternating Bass method for 3/4 meter would consist of substituting a 'down-up' strum for the first single down strum in the pattern. The 3/4 variation pattern would be as follows:

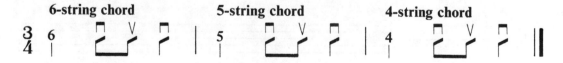

*"Etc." indicates that the correct patterns are to be used throughout the rest of the exercise; whether the chord is a 6, 5, or 4-string chord will determine the correct pattern to be used.

Try the following exercises using the 3/4 alternating bass variation:

Try the following songs from the Song Section (or other music in 4/4 or 3/4 meter) using the Alternating Bass method and variations for 4/4 and 3/4.

Silent Night, p. 67

Clementine, p. 73

Down in the Valley, p. 74

Home on the Range, p. 84

When the Saints Go Marching In, p. 72

Tom Dooley, p. 74

Oh, Suzanna, p. 78

Kum Ba Yah, p. 78

Cripple Creek, p. 83

Amazing Grace, p. 71

5

FINGERPICKING

FINGERPICKING—TRAVIS STYLE

After you feel comfortable doing the Alternating Bass patterns, you are ready to move on to one of the most popular types of accompaniment in folk and popular music, that of fingerpicking. The flat pick (plectrum) is not used in this style. We will begin with what is commonly referred to as the Travis style fingerpick in which the thumb and the first two fingers of the right hand are used. The position of the right hand should be tilted slightly so when the fingers pick upward and the thumb picks downward they will avoid running into each other (see drawings in the front of the book). The free stroke (see p. 9 for free stroke description) should be used when fingerpicking.

Remember that on some chords you may strum 6 strings, some you may strum 5, and some 4. This is important because the fingerpick patterns that are to be used for each chord depend on how many strings may be strummed. Travis style fingerpick patterns for one measure of a 6-string, 5-string, and 4-string chord are shown below. The numbers indicate the string to be picked. The order in which the strings are picked is left to right. The right hand fingers used to pick the strings are indicated on the pattern for a 6-string chord (fingering). p indicates thumb, i is the index finger, and m is the middle finger. The thumb will always pick downward and the fingers will pick upward. The rhythm is written on the pattern for a 5-string chord. The same fingering and rhythm is used for all three patterns.

Hold the chords suggested in the examples (ex.) under each pattern and play the patterns. For example, to play one measure of a 5-string chord, first, pick the 5th string with the thumb, then pick the 2nd string with the second finger, the 4th string is then picked with the thumb, next, the 3rd string is picked with the first finger. This sequence is then repeated to complete one measure. One measure of a G chord (G being a 6 string chord) would be picked 62436243. (See p. 3 for Right Hand Fingering)

6-String Chord	**5-String Chord**	**4-String Chord**
$\frac{4}{4}$ 6 2 4 3 6 2 4 3 —string	5 2 4 3 5 2 4 3 —string	4 1 3 2 4 1 3 2
p m p i p m p i —fingering	1 & 2 & 3 & 4 & —rhythm	
(ex. G and Em)	(ex. C and Am)	(ex. F and D)

There could be much disagreement as to exactly what pattern is the Travis pick style. For the purposes of this book the Travis style is characterized by the alternating of the thumb, keeping a steady rhythm in the bass (on the beat), and the fingers picking with, and between the thumb strokes.

The patterns may be practiced first alternating the thumb and the first finger, then the proper fingering is p—m—p—i—p—m—p—i.

Try the following example using the Travis pick style. At first you may use the thumb and the first finger only, then use the proper fingering. The same finger order is used to pick all three categories of chords. If a measure does not have the pattern written in, use the proper pattern for the chord played in that measure.

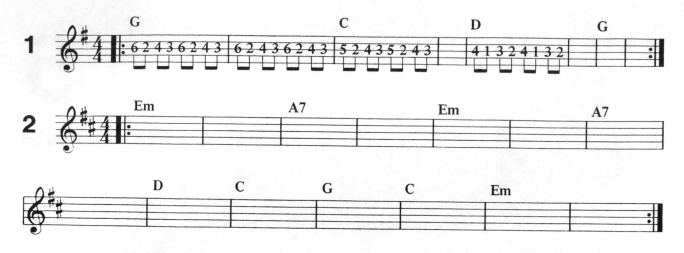

KEEP THE RHYTHM A STEADY EIGHTH NOTE PATTERN (one-and-two-and-three-and-four-and). The rhythm is sometimes indicated by stems on the numbers; one stem means that a stroke gets one count (6); two numbers connected mean there are two-strokes or picks to a count (4 3). This fingerpicking style can be used to play *any* song that is in 4/4 meter.

Try the following example using the Travis pick style and remember you may play each measure of the examples two times for the sake of practice, but eventually play the example as it is written.

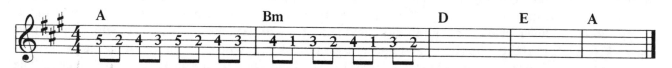

Music will seldom have the fingerpick patterns written out. Therefore the patterns must be memorized and used to play songs in the proper meter.

Try the songs listed below using the Travis pick patterns. You may also substitute music in 4/4 meter (one chord per measure). Each time a new fingerpick pattern is presented throughout this book, the same fingering (fingers used to pick the strings) and rhythm that is indicated under one category of chords (**6-string chords**) is used on all three categories of chords.

This Train, p. 68
Michael Row the Boat Ashore, p. 68
Worried Man Blues, p. 69
She'll Be Comin' Round the Mountain, p. 70

He's Got the Whole World, p. 71
Jingle Bells, p. 76
John Henry, p. 85
Oh, Sinner Man, p. 82

Remember: (1) each pattern takes one complete measure (2) keep the rhythm steady (3) be sure the thumb alternates smoothly (4) watch the position of the right hand (5) be careful not to let the right hand "bounce" when picking.

There are many variations of this style of picking. For example, the first variation consists of leaving out the second string to be picked, and where the picking of that string would have occurred, pause. The rhythm for this pattern is counted 1–2 & 3 & 4 & . The patterns for this variation are shown below:

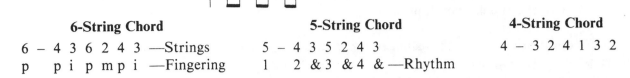

6-String Chord	5-String Chord	4-String Chord
6 – 4 3 6 2 4 3 —Strings	5 – 4 3 5 2 4 3	4 – 3 2 4 1 3 2
p p i p m p i —Fingering	1 2 & 3 & 4 & —Rhythm	

(Each pattern takes one measure of 4/4 to complete.)

The proper fingering is indicated on the 6-string pattern. The rhythm is indicated on the 5-string pattern.

Try this style or variation with the following examples (notice this fingerpick style can be used for any song in 4/4 meter).

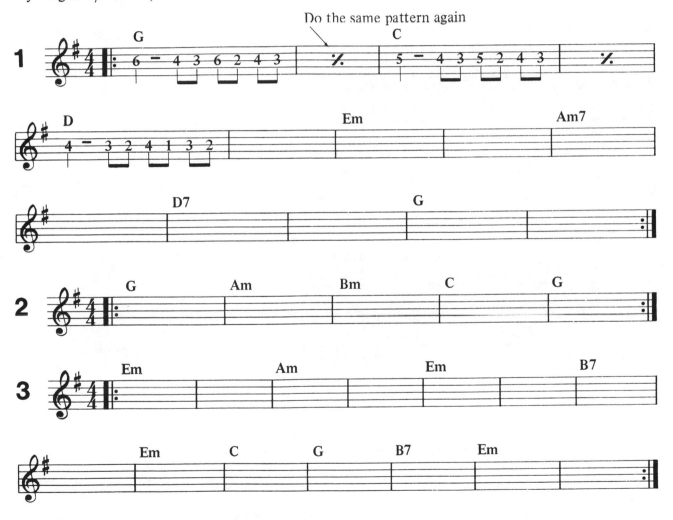

Try the following songs from the Song Section (or other music in 4/4 which has no more than one chord per measure) using variations of the Travis pick.

Worried Man Blues, p. 69 Michael, Row the Boat Ashore, p. 68
He's Got the Whole World, p. 71 John Henry, p. 85

Other variations of the Travis fingerpick style are listed below. Each one should be mastered before moving on to the next. Remember, the numbers on the top indicate the order the string is to be picked: the numbers on the bottom of the patterns for the 6-string chords indicates the rhythm to be used. If one number appears on top of another number in the pick sequence, this indicates that two strings are to be played at the same time, and usually with the thumb picking the lower note and the second finger picking the upper note. Right hand fingerings are indicated below the patterns for the 5-string chords. Each pattern takes one measure of 4/4 to complete.

6-String Chord	**5-String Chord**	**4-String Chord**
6 – 4 3 6 2 4 3 —Strings	5 – 4 3 5 2 4 3 —Strings	4 – 3 2 4 1 3 2 —Strings
p p i p mp i —Fingering	1 2 &3 &4 &—Rhythm	
1 ◄————————m, 2nd finger	1	1
6 – 4 3 6 2 4 3	5 – 4 3 5 2 4 3	4 – 3 2 4 1 3 2
p p i p mp i —Fingering	1 2 &3 &4 &—Rhythm	
1	1	1
6 – 4 3 6 2 4	5 – 4 3 5 2 4	4 – 3 2 4 1 3
p p i p mp —Fingering	1 2 &3 &4 —Rhythm	
6 – 3 2 6 1 3 2	5 – 3 2 5 1 3 2	4 – 3 2 4 1 3 2
p p i p mp i —Fingering	1 2 &3 &4 &—Rhythm	
1	1	1
6 – 4 3 5 2 4 3	5 – 4 3 6 2 4 3	4 – 3 2 5 1 3 2
p p i p mp i —Fingering	1 2 &3 &4 &—Rhythm	
1	1	1
6 4 6 2 4 3	5 4 5 2 4 3	4 3 4 1 3 2
p p p mp i —Fingering	1 2 3 &4 & —Rhythm	
6 3 4 2 6 3 4 2	5 3 4 2 5 3 4 2	4 2 3 1 4 2 3 1
p i p mp i p m—Fingering	1 &2 &3 &4 &—Rhythm	
1	1	1
6 – 4 2 6 3 4 2	5 – 4 2 5 3 4 2	4 – 3 1 4 2 3 1
p p mp i p m—Fingering	1 2 &3 &4 &—Rhythm	

Do the basic 4/4 Travis pick and then try the same pieces working your way up to the more complex patterns.

If two chords appear in a measure, split their individual patterns in half. Divide the rhythm so there are 2 beats per chord, such as:

$\frac{4}{4}$ | G C |
 | 6 2 4 3 5 2 4 3 |

$\frac{4}{4}$ | 6–4 3 5 2 4 3 |
 | 1 2 & 3 &4 & |

G
$\frac{4}{4}$ | 1 C |
 | 6–4 3 5 2 4 3 |

$\frac{4}{4}$ | 1 |
 | 6–4– 5 2 4 3 |

Do the first half of the fingerpick pattern and the second half of the fingerpick pattern. You may also do the second half of the fingerpick pattern for each chord. See the following example:

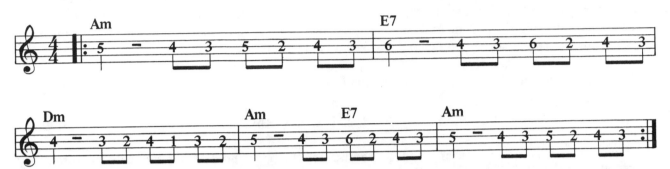

Try the following example:

Try the following songs from the Song Section (or other 4/4 music in which some measures contain two chords) using the Travis pick patterns:

Midnight Special Blues, p. 72
Oh, Suzanna, p. 78
When the Saints Go Marching In, p. 72
Aura Lee, p. 77

Tom Dooley, p. 74
Kum Ba Yah, p. 78
Red River Valley, p. 77
Cripple Creek, p. 83

Different Travis patterns may be used in the same song. Try the following example which combines some of the patterns. Some possible patterns have been written in.

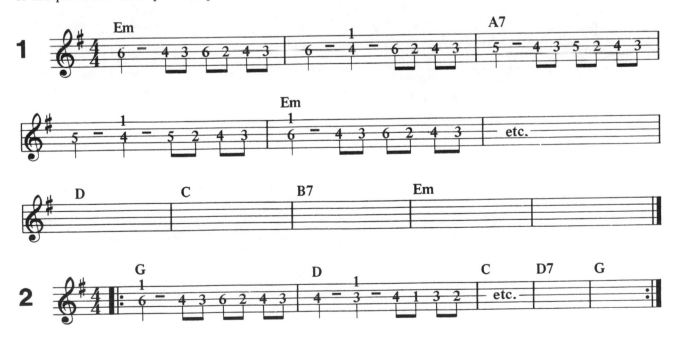

Try the Travis variations on the following songs from the Song Section (or other music in 4/4 meter):

She'll Be Comin' Round the Mountain, p. 70 Jingle Bells, p. 76
This Train, p. 68 Oh, Sinner Man, p. 82
Michael, Row the Boat Ashore, p. 68 John Henry, p. 85

FINGERPICKING—3/4 Meter

There are also many ways to do the fingerpicking style in 3/4 meter. One of the most common pick patterns for 3/4 is outlined below. Each pattern completes one measure in 3/4 meter. This is done with a steady rhythm, counted as "one and two and three and." The 3/4 fingerpick patterns for one measure of a 6-string, 5-string, and 4-string chord are shown below (note the proper fingerings).

6-String Chord		5-String Chord	4-String Chord
6 4 3 2 4 3	—String	5 4 3 2 4 3	4 3 2 1 3 2
p p i m p i	—Fingering	1 & 2 & 3 & —Rhythm	

Notice here again the fingering and the rhythm for the 6, 5, and 4-string chords is the same. Try fingerpicking the following example. For review also try using the strums for 3/4 on the following example:

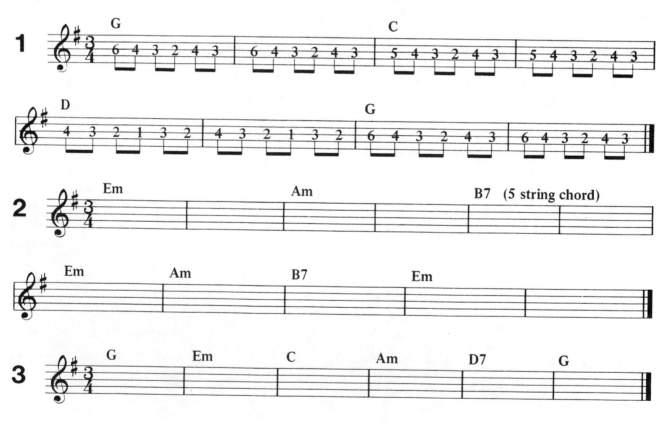

Try the following songs from the Song Section (or other music in 3/4 meter) using the 3/4 fingerpick patterns found on this page. The 3/4 fingerpick patterns may be used to play *any* song in 3/4 meter.

When Johnny Comes Marching Home, p. 66
Silent Night, p. 67
Clementine, p. 73
Amazing Grace, p. 71

On Top of Old Smokie, p. 73
Down in the Valley, p. 74
A Poor Wayfaring Stranger, p. 80

Other patterns for 3/4 meter are also possible; some are below:

6-String Chord	5-String Chord	4-String Chord
1—m (second finger)	1	1
6 4 3 2 4 3 —String	5 4 3 2 4 3	4 3 2 1 3 2
p p i m p i —Fingering	1 & 2 & 3 & —Rhythm	
2 2 —m	2 2	1 1
6 4 3 4 3 4	5 4 3 4 3 4	4 3 2 3 2 3
p p i p i p	1 & 2 & 3 & —Rhythm	

(Each pattern takes one measure of 3/4 to complete.)
Hold 6, 5, or 4-string chords and practice the above patterns.
Practice the following using these new 3/4 patterns.

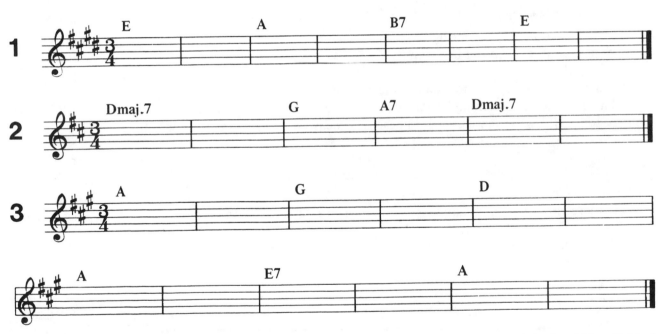

If two or more chords exist in a measure together, the rhythm of the fingerpick should be divided between the chords, one getting one beat and the other getting two beats; or the fingerpick may be stopped altogether and the chords in that measure may simply be strummed. The chord which appears over the larger portion of the measure gets two beats and the other chord receives one beat. If more than two chords appear in a measure, eliminate one or stop fingerpicking for that measure and strum each chord down once.

Practice the following which has a measure containing two chords.

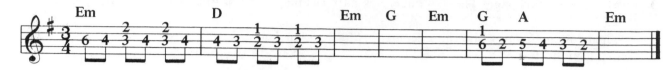

Try the following songs from the Song Section (or other music in 3/4 meter) using the new 3/4 pick patterns.

Silent Night, p. 67

My Bonnie, p. 79

Home on the Range, p. 84

Amazing Grace, p. 71

Streets of Laredo, p. 70

It Came Upon a Midnight Clear, p. 75

Scarborough Fair, p. 86

STRAIGHT FINGERPICKING STYLE

Still another form of fingerpicking accompaniment for 4/4 meter is the straight-pick style. It is called the straight-pick because the strings are picked in a straight down order (6432). The straight-pick is sometimes referred to as the "Arpeggio" style fingerpick. The straight-pick patterns for one measure of a 6-string, 5-string, and 4-string chord are shown below. The same rhythm and fingering is used for all three categories of chords.

6-String Chord

6 4 3 2 6 4 3 2 —String

p p i m p p i m —Fingering

5-String Chord

5 4 3 2 5 4 3 2

1 & 2 & 3 & 4 & —Rhythm

4-String Chord

4 3 2 1 4 3 2 1

Hold 6, 5, or 4-string chords and practice the above patterns.

This style of fingerpicking is adapted to *any* slow piece in 4/4 meter. It does not work well on fast, bouncy songs. If two or more chords appear in a measure, the pattern may be split in half.

G C
6432 5432

If more than two chords appear in the measure, eliminate one or more of them leaving no more than two chords in each measure.

Try the following examples using the straight-pick patterns:

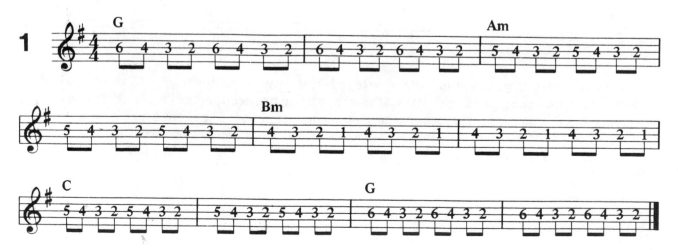

Try the following songs from the Song Section (or other music in 4/4 meter) using the straight-pick style:

Michael, Row the Boat Ashore, p. 68 Shenandoah, p. 81
 Aura Lee, p. 77

One variation of the straight-pick pattern is to pick two strings together at the first of each pattern. The patterns for one measure of a 6-string, 5-string or 4-string chord are shown below:

6-String Chord	**5-String Chord**	**4-String Chord**
1—m (second finger)	1	1
6 4 3 2 6 4 3 2	5 4 3 2 5 4 3 2	4 3 2 1 4 3 2 1
p p i m p p i m —fingering	1 & 2 & 3 & 4 & —Rhythm	

Remember, the rhythm should remain steady and the chord changes smooth and even.
Try the following example using the straight-pick variation:

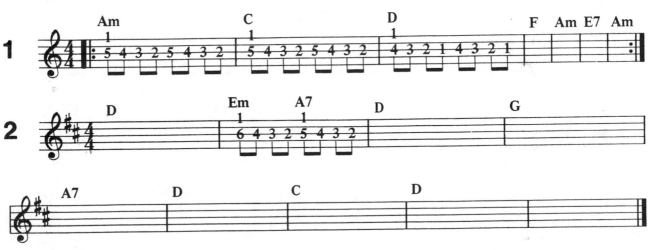

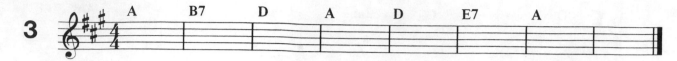

Try the following songs from the Song Section (or other music in 4/4) using the straight-pick variation:

Michael, Row the Boat Ashore, p. 68
Kum Ba Yah, p. 78
Aura Lee, p. 77

Oh, Sinner Man, p. 82
Shenandoah, p. 81

OFF-BEAT FINGERPICKING STYLE

The off-beat pick style works well when playing slow songs in 4/4. The patterns for one measure of a 6-string, 5-string, or 4-string chords are shown below:

6-String Chord

1			1—m (second finger)
6	4	3	6 4 3 2 3
p	p	i	p p i m i —fingering

5-String Chord

1	1
5 4 3	5 4 3 2 3
1 &2 &3	&4 & —Rhythm

4-String Chord

| 1 | 1 |
| 4 3 2 | 4 3 2 1 2 |

The rhythm should be steady eighth notes (1&2&3&4&). If two chords appear in one measure the straight-pick should be used to play the measure containing two chords and the off-beat pick used on the measure containing one chord.

Try the following exercise using the off-beat pick style:

Try the following songs from the Song Section (or other music in 4/4 meter) using the off-beat pick style:

Kum Ba Yah, p. 78
Aura Lee, p. 77
Oh, Sinner Man, p. 82

Shenandoah, p. 81
Michael, Row the Boat Ashore, p. 68

6

Music Theory

READING REPEAT SIGNS

This (:‖) is called a repeat sign. When it appears in the music, you should go back to where this sign (‖:) appears previously in the piece and play that much of the song again. After repeating, you should end the piece or continue on.

These are first and second endings. The first time you play through the piece, play the first ending then repeat to the repeat sign. The second time through the piece, you should skip the first ending (⌐¹————⌐) and play the second ending

⌐²————

D. S. al ⊕ Coda 𝄋 is also an instruction to repeat. When you play the piece to where D. S. 𝄋 al Coda appears, you should go back to where this sign (𝄋) appeared earlier in the piece and play to the following sign: ⊕ to Coda. Then you should skip from this sign ⊕ to Coda to the Coda (⊕), or ending, of the piece (indicated: ⊕ CODA).

D. C. al Coda means to go from the place this instruction appears to the beginning of the piece and play to where to Coda ⊕ appears. Then you should skip from to Coda ⊕ to the Coda (⊕) or ending.

If D. C. al Fine appears above a measure, repeat from the place that term occurs to the beginning of the song, and play to where the word "Fine" appears. "Fine" means finish or end.

THE CAPO

The capo is a clamp which can be fastened on the neck of the guitar and raise the pitch of the strings. The further up the neck the capo is placed, the higher the pitch. To use a capo, clamp it next to the desired fret. Finger the chords as if the first fret up the neck from the capo were the first fret on the guitar. The chord finger patterns will still be the same but the pitches of the chords will be higher.

The use of the capo changes the key, however, the same chord patterns are used that were used previously without the capo. The use of the capo may put songs in a key that is easier for you to sing. Each time the capo is moved up one fret, it raises the key (or pitch) 1/2 step. For example, to place the capo in the 2nd fret raises the pitch of the chords two half steps, or one whole step.

THE CHORD CLOCK (Circle of Fifths)

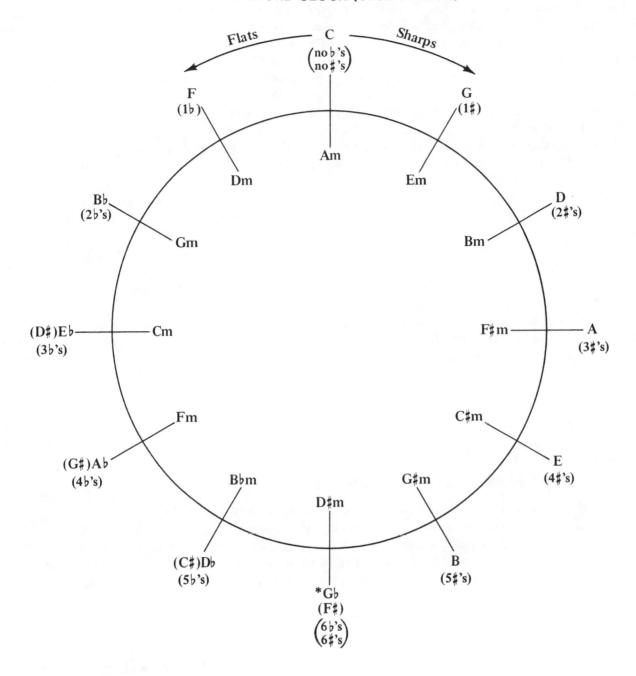

This is a chord clock. It can be used in three ways:

1. It can be used to determine the number of sharps or flats in a given key.
2. It can be used to determine the basic chords in a key.
3. It can be used to transpose music. This means to change the key.

You can determine the key of a particular piece by looking at the key signature. The key signature is the sharps or flats found at the beginning of each staff. The number of sharps or flats in the key signature determines the key in which the piece is written. If a piece has one or more sharps in its key signature, it will be in one of the keys on the right half of the chord clock. If a piece has one or more

*F♯ and G♭ are *enharmonic*. This means the same pitch for two different note names.

flats in its signature, it will be in one of the keys on the left half of the clock. For example, the key of C or Am will have no sharps or flats in its key signature. The key of G or Em will have one sharp sign in its signature, the key of D or Bm will have two sharps in its signature, the key of A or F♯m will have three sharps in its signature, etc. The key of F or Dm will have one flat in the signature, the key of B♭ or Gm will have two flats in the signature, the key of E♭ or Cm will have three flats, etc.

You can determine the six basic chords in a given key by also using the chord clock. To find the basic chords in a key, take the chord having the name of the key (key chord) and the first chords to the right and to the left of it. Those three chords and their related chords (chords on the inside of the clock will correspond with the outside chords) make up the six basic chords in any given key. For example, to find the chords in the key of G, find G on the chord clock. Use the chords to the right and left of it (C and D) and their related chords (A minor, B minor, E minor) to give you the six basic chords in the key of G. The chords would be G, C, D, Am, Em, and Bm.

This process can be very helpful to the person who wants to play a piece by ear. If you want to play "Down in the Valley" without the use of music, choose the key you want to use. For instance, use the key of G. You know that the six basic chords for that key are G, C, D, Am, Em, Bm. Start by singing the melody and strumming a G chord (most simple folk songs begin with the key chord); then, when it sounds like the melody you are singing conflicts with the chord you are playing, change to one of the other chords in the key. If you change to a chord that still conflicts, change to another chord in the key until you find the one that sounds correct.

The chord clock can also be used to transpose (change the key). The easiest keys for the guitar are G, C, and D and Em, Am, and Bm. If you want to make the chords in a piece simple, play the song in one of these keys. Suppose a piece is written in a different key and the chords look like the ones in the example below:

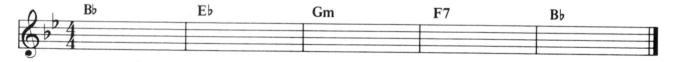

These chords can be transposed and made simple by:

1. Changing the first chord in the piece to one of the simple key chords (G, C, D, etc.)
2. Finding on the chord clock the original first chord in the piece.
3. Finding the new chord on the clock you are changing the original chord to.
4. Seeing which direction and the number of steps you went to change the old chord to the new chord.
5. Changing the rest of the chords in the piece the same number of steps and in the same direction as the first chord was changed.

Example

Change the first B♭ chord to a G chord. Then, find B♭ on the clock and notice that we had to go four steps (counting the B♭ chord as #1) clockwise to get to a G chord. Now, we change the rest of the chords in the piece four steps clockwise. Notice that the number of steps and the direction you change the first chord in the piece will determine the number of steps and the direction you change the rest of the chords. Shown below are the original chords and the new chords to the example:

| G ← new | C | Em | D7 | G |
| B♭ key | E♭ | Gm | F7 | B♭ |

The minor chords will change the same direction and number of steps but will remain on the inside of the clock. To transpose 7th chords such as the F7 in the example, find F on the clock, change it to the new chord (D), then, add the 7th to the chord name. The F7 is changed to a D7. The same principle applies to m7, 9, 13, and other various chords.

Assignments using the chord clock:

1. Transpose two songs from sheet music or music book to easy keys for the guitar.
2. Write one original song (just the chords).
3. Write out the lyrics to one familiar song putting the correct chord changes above the words (rhythm sheet).

7

READING SINGLE NOTE MELODIES

TERMS FOR NOTE READING

 STAFF: Consisting of five lines and four spaces.

LEGER LINES

NOTE: Assumes the name of the line or space of the staff on which it appears.

BEAT: A unit, or measurement of time.

 TIME SIGNATURE: The top number indicates the number of beats per measure.
The bottom number indicates which note gets one beat.
In this case, a quarter note would get one beat.

METER: The number of beats per measure.

TEMPO: The speed of the music.

 TREBLE CLEF: Indicating that the second line from the bottom is named "G."
G

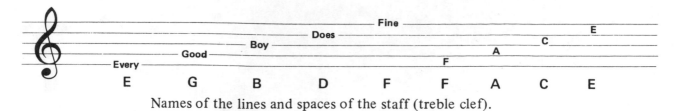

Names of the lines and spaces of the staff (treble clef).

Bar line

MEASURE: The space between two bar lines on the staff indicating a complete beat pattern (♩ ♩ ♩).

RHYTHMS

The following time values of the notes are given assuming that the bottom number of the time signature in the music is 4. The quarter note would get the basic unit or one beat. If the bottom number of the time signature were 8, then the eighth note would get one beat and the time values of the following notes would be double.

	NAME	TIME VALUE
♩	Quarter Note.	1 beat
♩	Half note—pick the note on the 1st beat and let it sound through the 2nd beat.	2 beats
♩.	Dotted half note. The dot increases the length of the note by ½ its original time value.	3 beats
○	Whole note	4 beats
♪	Eighth note	½ beat
♩.	Dotted quarter note	1½ beats
♬	16th note	¼ beat
3 ♫	1 beat triplet	3 notes to 1 beat
3 ♩♩♩	2 beat triplet	3 notes to 2 beats
⸘	Quarter rest	1 beat
▬	Half rest	2 beats
▬	Whole rest	4 beats
૪	Eighth rest	½ beat

NOTES ON FOUR STRINGS

You may use a pick or your fingers to play the exercises. Fingerstyle players should use the rest stroke (see p. 9) to play each exercise and then use the free stroke. If the exercises are played fingerstyle, the first finger of the right hand should be used to play all of the notes then the second finger should be used to play all the notes. Finally, practice alternating fingers one and two (i and m).

If you are using a pick, play all of the notes with a down stroke.

Notes on the 1st String (First Position)

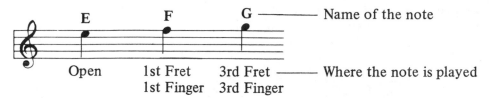

The number of the left hand finger used to play the note should be the same as the fret number. This is called "first position."

♩ This is a quarter note. It gets *one* beat if the bottom number of the time signature is 4.

Play the following example using the notes on the first string.

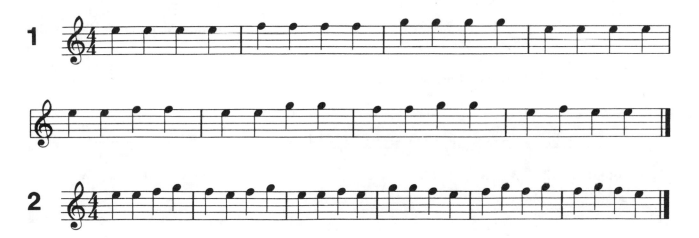

Notes on the 2nd String

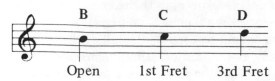

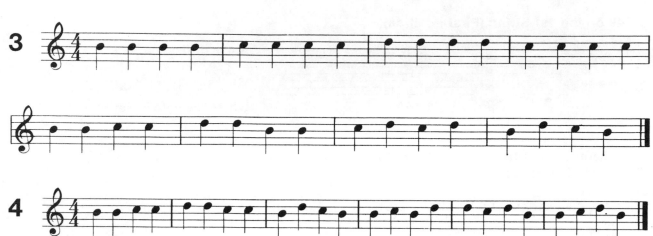

Combining the notes on the first two strings

♩ This is a half note. It gets *two* beats if the bottom number of the time signature is 4. Pick the note on the first beat and let it ring through the second beat.

Another guitarist may play these chords for the accompaniment.

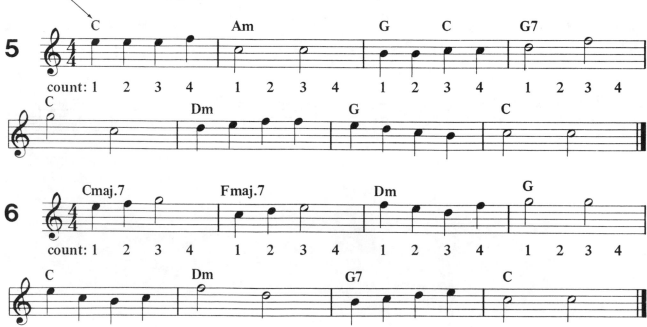

Merrily We Roll Along

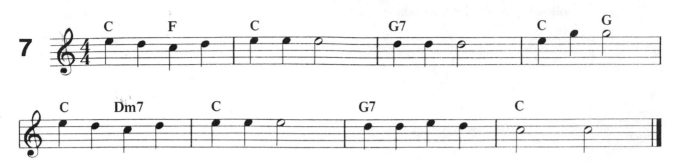

Song Of Joy *Beethoven*

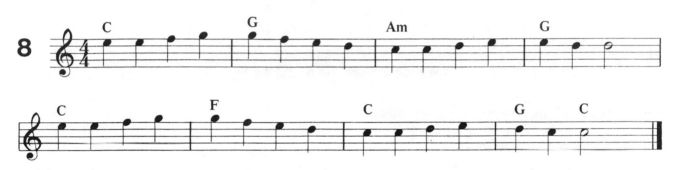

Notes on the 3rd String

Combining Strings 2 and 3

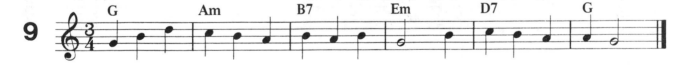

Oh Sinner Man

Play the following using the notes on the first three strings.

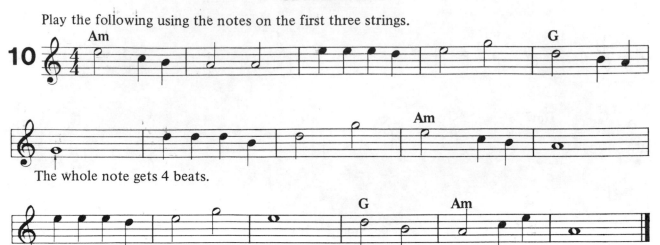

The whole note gets 4 beats.

When the Saints Go Marching In

If a song begins with an incomplete measure
then these are called "pick-up notes."
The missing beat is in the last measure.

This is a quarter rest. Rest (do not
play or hold anything) for one beat.

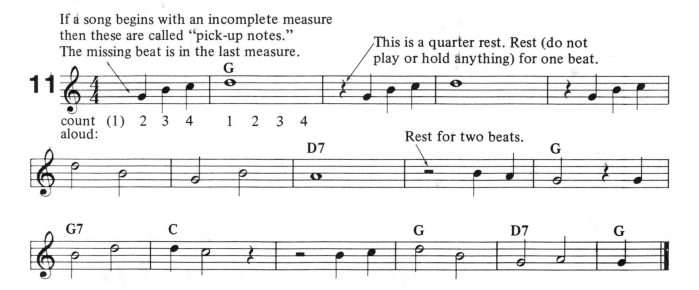

count (1) 2 3 4 1 2 3 4
aloud:

Rest for two beats.

Notes on the 4th String

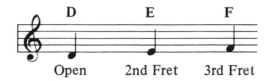

Play the following using the notes on the fourth string. Fingerstyle players should use the thumb to play these notes.

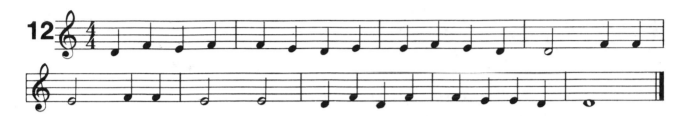

Red River Valley

Play the following using the notes on four strings.

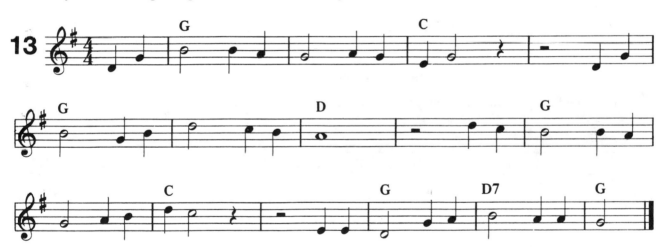

4 String Tune

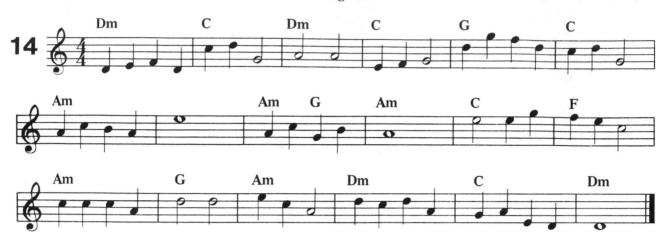

DOTTED HALF NOTES AND TIES

 • The dot behind the note lengthens the note by one half its original value.
The dotted half note gets three beats.

This is called a tie. The first note is played and held throughout the time value of the second note. The second note is not played.

When Johnny Comes Marching Home

Play the following melody containing ties and dotted half notes.

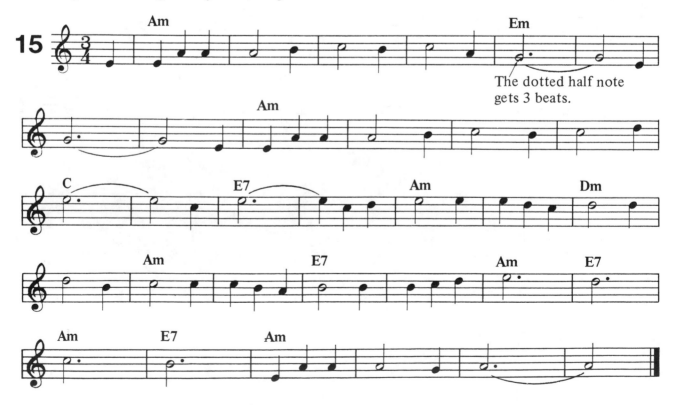

SHARP AND NATURAL SIGNS

♯ This is a sharp sign. When it appears in front of a note, play that note one fret (or ½ step) higher (toward the body). If an open string is sharp, it is played in the first fret.

When a sharp sign appears, it will affect all of the notes with the same name in that measure unless a natural sign ♮ appears in front of the note. The natural sign cancels a previous sharp or flat.

Play the following containing sharps and natural signs.

Scarborough Fair *Trad.*

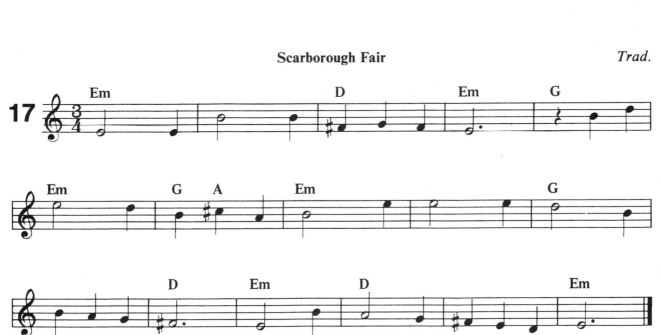

Greensleeves *Trad. English air*

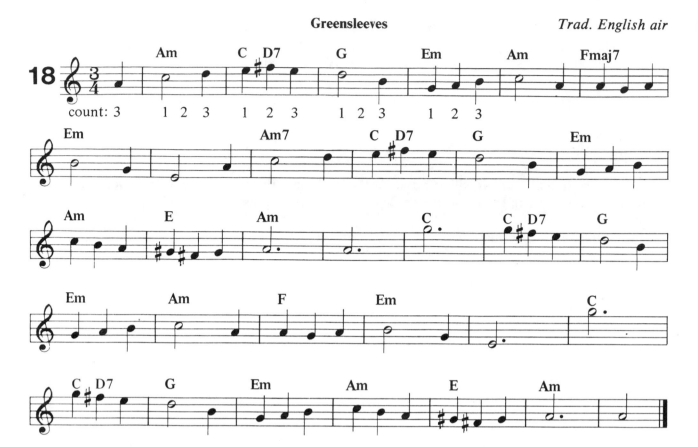

A *scale* is an orderly sequence of notes.
An *octave* is the distance between two notes having the same name.
Practice the following One Octave G Major Scale.

NOTES ON THE 5th AND 6th STRINGS

Fingerstyle players should use the thumb to play the notes on strings 5 and 6.

Notes on the 5th String

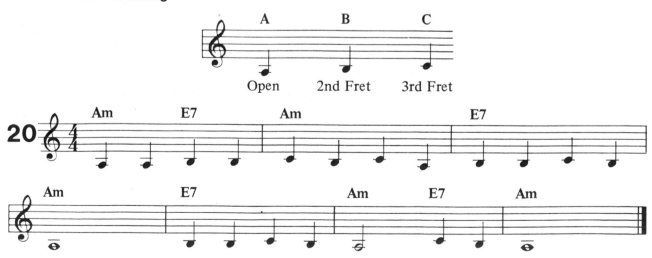

Notes on the 6th String

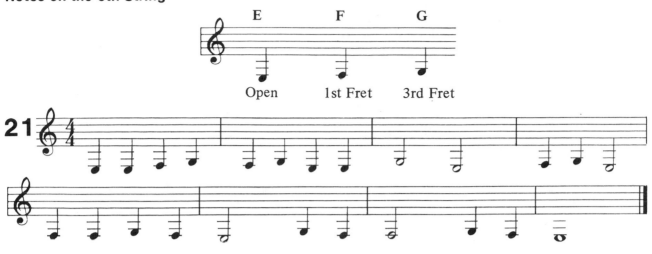

House of the Rising Sun

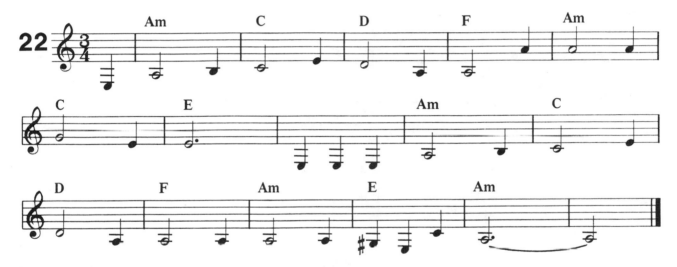

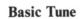

Basic Tune

FLATS

♭ This is a flat sign. When it appears in front of a note, play that note one fret (½ step) lower. To flat an open string, go to the next lower string and place a finger in the fret that matches the open string, then flat the note by moving it down one fret.

Play the following using flats and naturals.

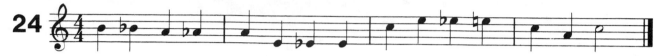

Play the following tunes containing flats.

God Rest Ye Merry Gentlemen

Old English Carol

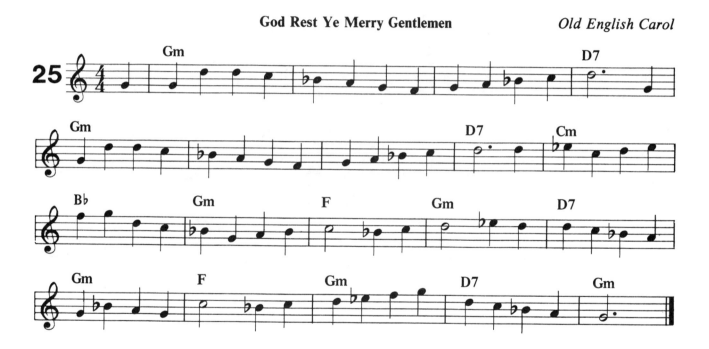

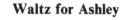

Waltz for Ashley

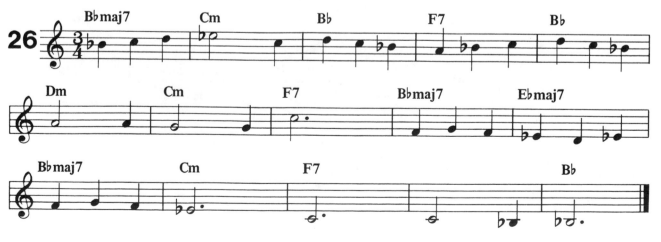

8

SONG SECTION

Table of Contents

When Johnny Comes Marching Home

Julian Edwards

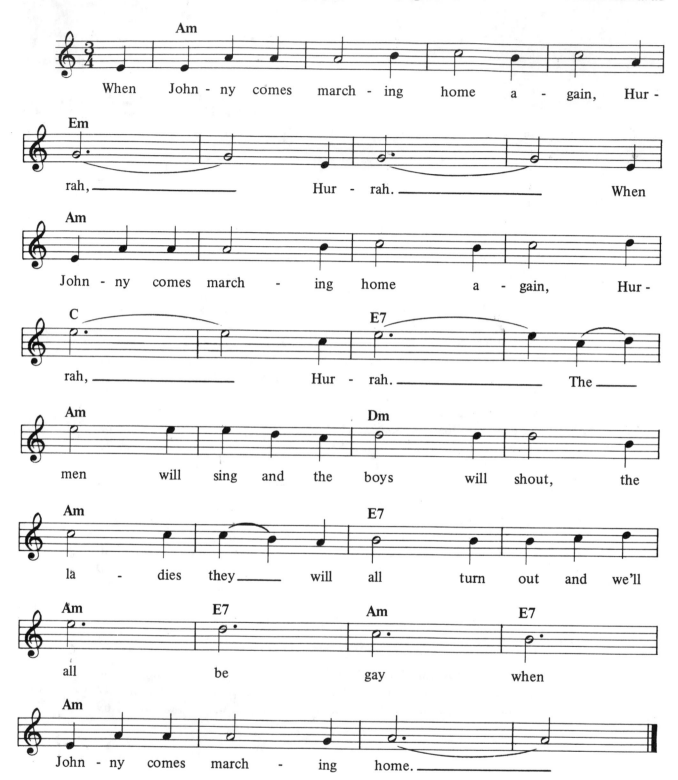

When John - ny comes march - ing home a - gain, Hur -

rah, _____ Hur - rah. _____ When

John - ny comes march - ing home a - gain, Hur -

rah, _____ Hur - rah. _____ The _____

men will sing and the boys will shout, the

la - dies they _____ will all turn out and we'll

all be gay when

John - ny comes march - ing home. _____

Silent Night

Franz Grüber

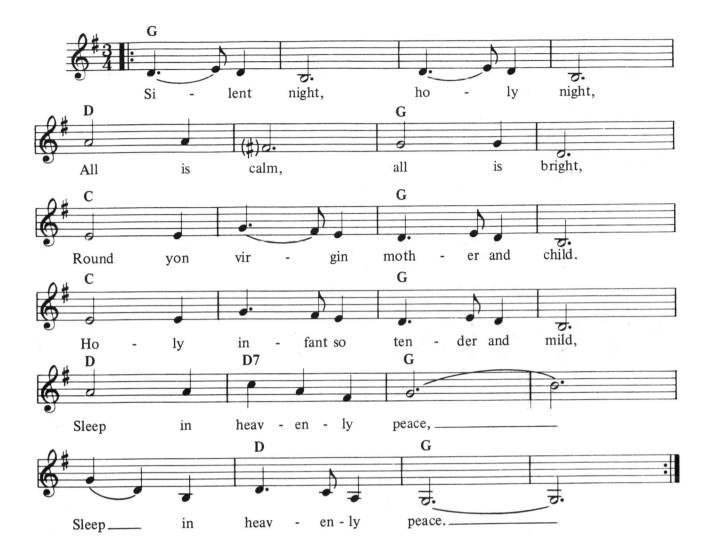

Si - lent night, ho - ly night,

All is calm, all is bright,

Round yon vir - gin moth - er and child.

Ho - ly in - fant so ten - der and mild,

Sleep in heav - en - ly peace,

Sleep in heav - en - ly peace.

ADDITIONAL VERSE:

2. Silent night, holy night,
 Sheperds quake, at the sight,
 Glories stream from heaven afar,
 Heavenly hosts sing Alleluia;
 Christ the Savior is born!
 Christ the Savior is born!

This Train

Spiritual

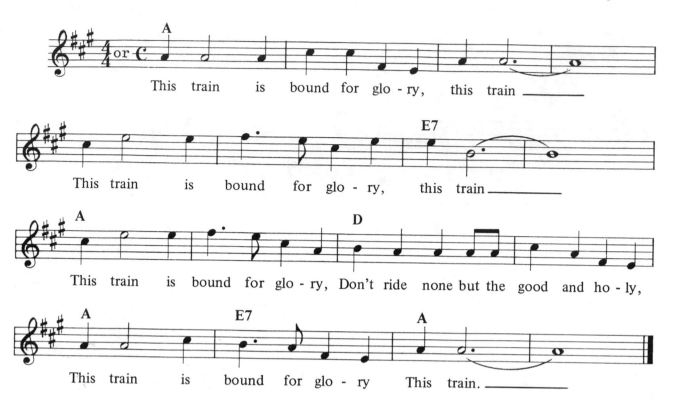

This train is bound for glo - ry, this train ____

This train is bound for glo - ry, this train ____

This train is bound for glo - ry, Don't ride none but the good and ho - ly,

This train is bound for glo - ry This train. ____

Michael, Row the Boat Ashore

Trad. South Carolina
Negro Spiritual

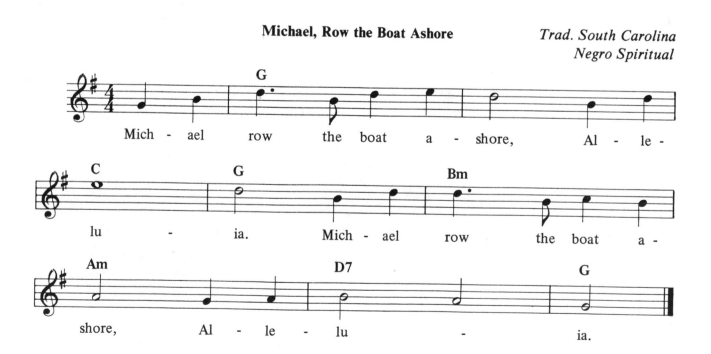

Mich - ael row the boat a - shore, Al - le -

lu - ia. Mich - ael row the boat a -

shore, Al - le - lu - ia.

Worried Man Blues *Unknown*

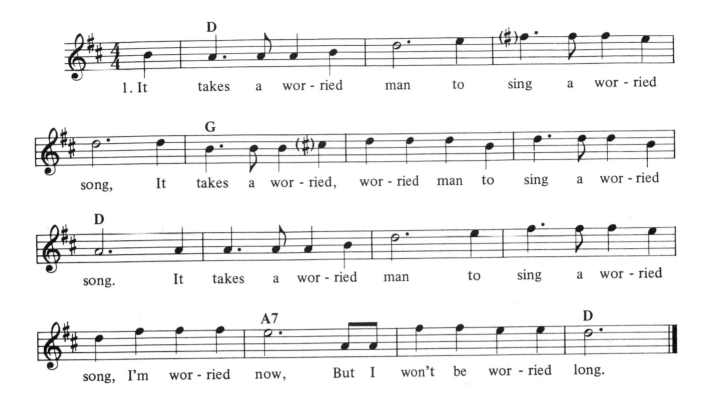

ADDITIONAL VERSES: (3 times)

2. I went across the river, and I lay down to sleep,
 When I woke up, had shackles on my feet.

3. Twenty-nine links of chain around my leg,
 And on each link, an initial of my name.

4. I asked that judge, tell me, what's gonna be my fine?
 Twenty-one years on the Rocky Mountain Line.

5. Twenty-one years to pay my awful crime,
 Twenty-one years — but I got ninety-nine.

6. The train arrived sixteen coaches long,
 The girl I love is on that train and gone.

7. I looked down the track as far as I could see,
 Little bitty hand was waving after me.

8. If anyone should ask you, who composed this song,
 Tell him was I, and I sing it all day long.

She'll Be Comin' Round the Mountain

Anon.

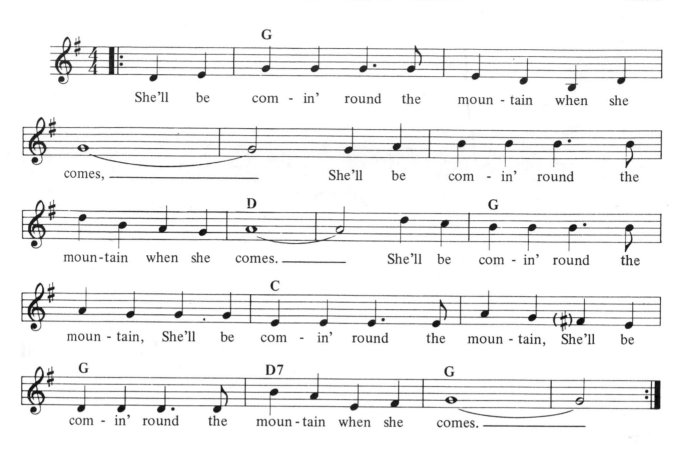

She'll be com - in' round the moun - tain when she comes, _____ She'll be com - in' round the moun - tain when she comes. _____ She'll be com - in' round the moun - tain, She'll be com - in' round the moun - tain, She'll be com - in' round the moun - tain when she comes. _____

Streets of Laredo

Western Song

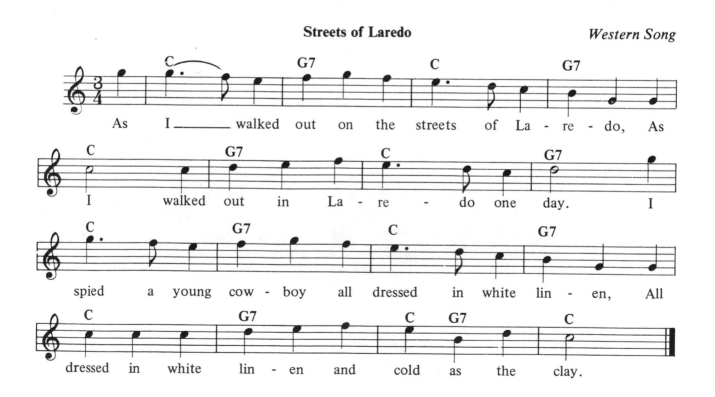

As I _____ walked out on the streets of La - re - do, As I walked out in La - re - do one day. I spied a young cow - boy all dressed in white lin - en, All dressed in white lin - en and cold as the clay.

Amazing Grace *Anon.*

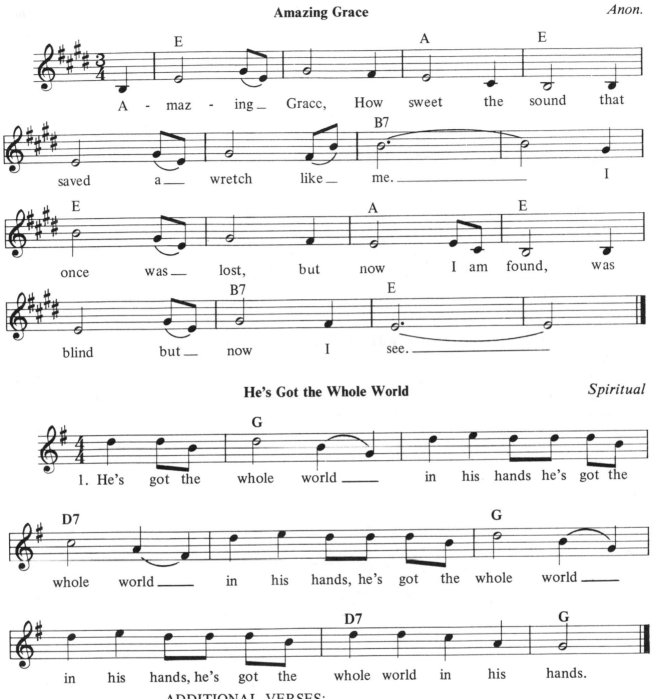

A - maz - ing_ Grace, How sweet the sound that
saved a_ wretch like_ me._____ I
once was_ lost, but now I am found, was
blind but_ now I see._____

He's Got the Whole World *Spiritual*

1. He's got the whole world ____ in his hands he's got the
whole world ____ in his hands, he's got the whole world ____
in his hands, he's got the whole world in his hands.

ADDITIONAL VERSES:

2. He's got you and me brother, in his hands
 He's got you and me sister, in his hands
 He's got you and me brother, in his hands
 He's got the whole world in his hands.

3. He's got the wind and the rain in His hands;
 He's got the sun and the moon right in His hands;
 He's got the wind and the rain in His hands.
 He's got the whole world in His hands.

4. He's got the little bitsy baby in His hands;
 He's got the tiny little baby right in His hands;
 He's got the little bitsy baby in His hands
 He's got the whole world in His hands.

When the Saints Go Marching In

Anon.

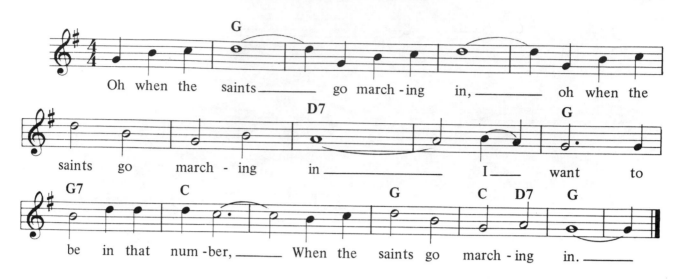

Oh when the saints _____ go march-ing in, _____ oh when the saints go march-ing in _____ I _____ want to be in that num-ber, _____ When the saints go march-ing in. _____

Midnight Special Blues

Unknown

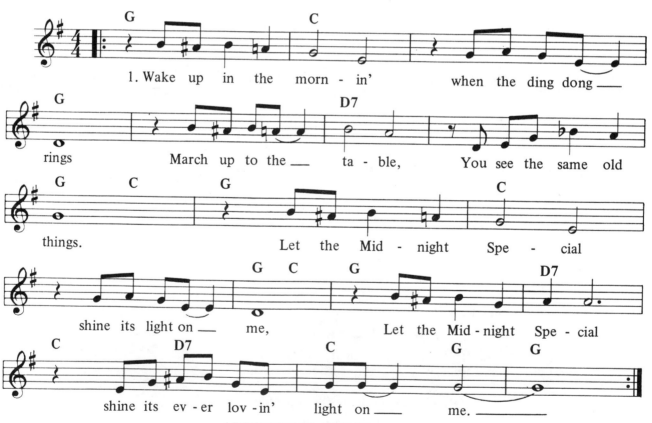

1. Wake up in the morn-in' when the ding dong _____ rings March up to the _____ ta-ble, You see the same old things. Let the Mid-night Spe-cial shine its light on _____ me, Let the Mid-night Spe-cial shine its ev-er lov-in' light on _____ me. _____

ADDITIONAL VERSE:

2. There upon the table
 Knife and fork and pan
 Say a word about it
 There's trouble with the man.

Clementine *Percy Montrose*

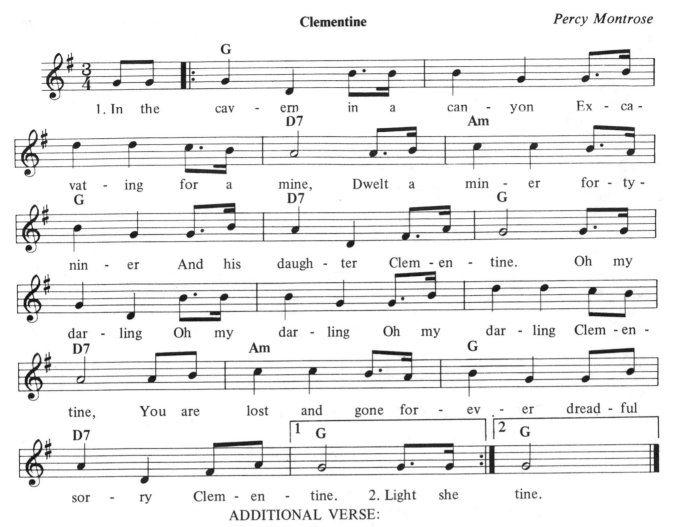

1. In the cav - ern in a can - yon Ex - ca -
vat - ing for a mine, Dwelt a min - er for - ty -
nin - er And his daugh - ter Clem - en - tine. Oh my
dar - ling Oh my dar - ling Oh my dar - ling Clem - en -
tine, You are lost and gone for - ev - er dread - ful
sor - ry Clem - en - tine. 2. Light she tine.

ADDITIONAL VERSE:

2. Light she was and like a fairy
 And her shoes were number nine,
 Herring boxes without topses,
 Sandals were for Clementine.

On Top of Old Smokie *Anon.*

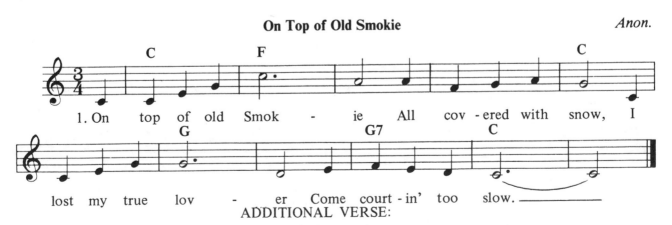

1. On top of old Smok - ie All cov - ered with snow, I
lost my true lov - er Come court - in' too slow. ____

ADDITIONAL VERSE:

2. A Thief always robs you
 And takes all you save
 But a false-hearted lover
 He sends you to your grave.

Tom Dooley

Trad. Cowboy Song

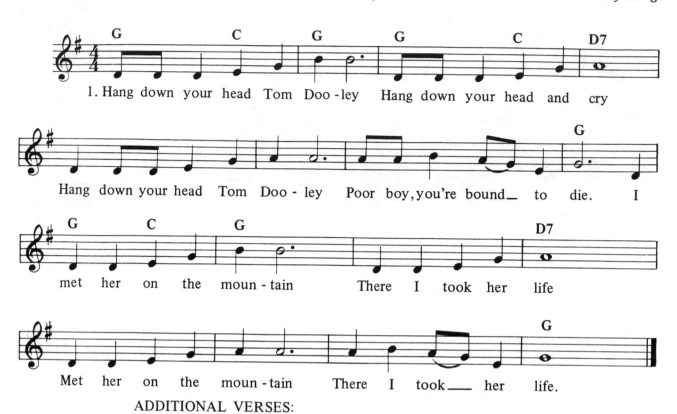

1. Hang down your head Tom Doo-ley Hang down your head and cry

Hang down your head Tom Doo-ley Poor boy, you're bound— to die. I

met her on the moun-tain There I took her life

Met her on the moun-tain There I took—— her life.

ADDITIONAL VERSES:

2. This time tomorrow, reckon where I'll be
 If it hadn't been for Grayson, I'd been in Tennessee.

3. This time tomorrow, reckon where I'll be
 Down in some lonesome valley, hangin' from a white oak tree.

Down in the Valley

Trad. Kentucky Mountain Song

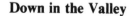
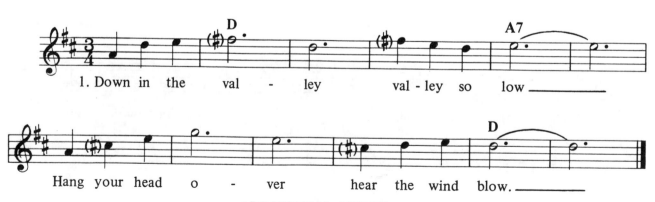

1. Down in the val - ley valley so low ————

Hang your head o - ver hear the wind blow. ——————

ADDITIONAL VERSE:

2. Hear the wind blow, dear
 Hear the wind blow
 Hang your head over
 Hear the wind blow.

It Came Upon a Midnight Clear

R. S. Willis

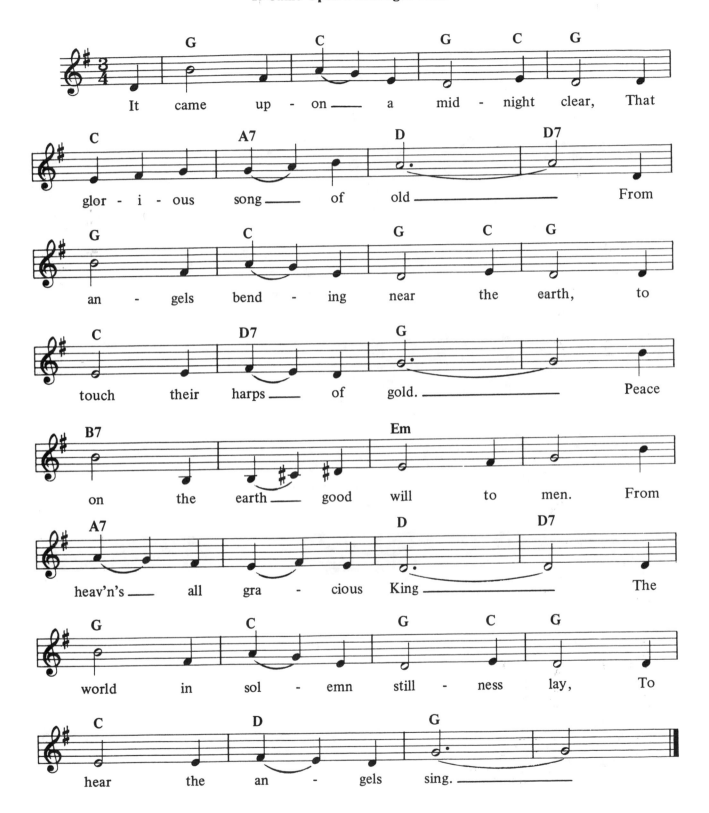

Jingle Bells

J. S. Pierpont

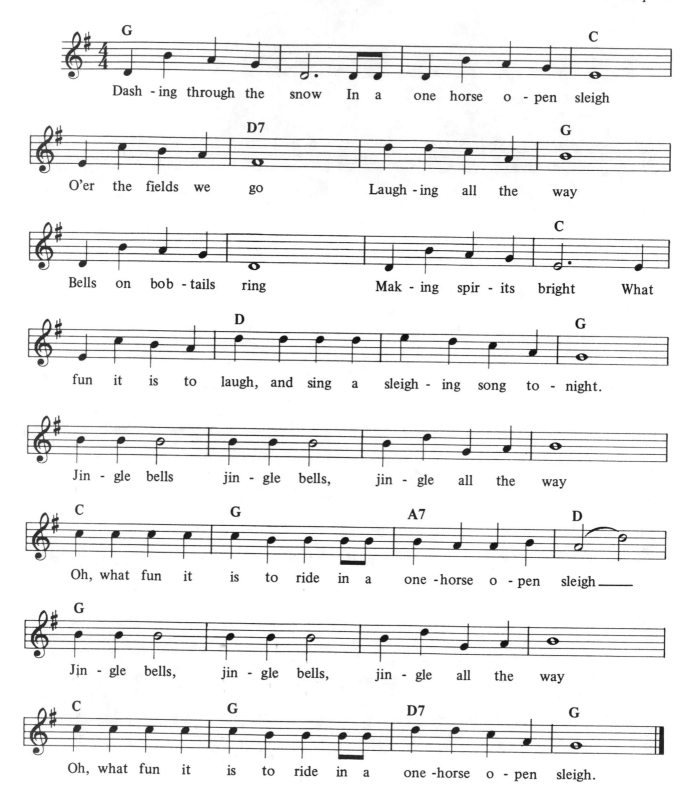

Dash - ing through the snow In a one horse o - pen sleigh

O'er the fields we go Laugh - ing all the way

Bells on bob - tails ring Mak - ing spir - its bright What

fun it is to laugh, and sing a sleigh - ing song to - night.

Jin - gle bells jin - gle bells, jin - gle all the way

Oh, what fun it is to ride in a one - horse o - pen sleigh ____

Jin - gle bells, jin - gle bells, jin - gle all the way

Oh, what fun it is to ride in a one - horse o - pen sleigh.

Red River Valley

Trad. Cowboy Song

1. From this val - ley they say you are go - ing, I will
miss your bright eyes and sweet smile. _____ For they
say you are tak - ing the sun - shine, _____ That
bright - ens our path - way a - while.

ADDITIONAL VERSE:

2. Come and sit by my side if you love me
 Do not hasten to bid me adieu
 But remember the Red River Valley
 And the girl who has loved you so true.

Aura Lee

G. R. Poulton

As the black - bird in the spring, 'neath the wil - low tree Sat and piped, I
heard him singin' praise of Au - ra Lee. Au - ra Lee, Au - ra Lee,
Maid of gold - en hair. Sun - shine came a - long with thee and swal - lows in the air.

Oh, Suzanna

Stephen C. Foster

Well, I come from Al - a - bam - a with my ban - jo on my knee. I'm — goin' to Louis - i - an - a, My — true love for to see. Oh, Suz - an - a Oh, don't you cry for me. 'Cause I come from Al - a - ba - ma with my ban - jo on my knee.

Kum Ba Yah

African Spiritual

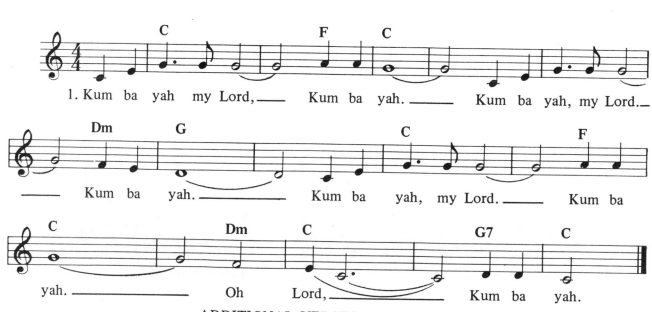

1. Kum ba yah my Lord, — Kum ba yah. — Kum ba yah, my Lord. — — Kum ba yah. — Kum ba yah, my Lord. — Kum ba yah. — Oh Lord, — Kum ba yah.

ADDITIONAL VERSES:
2. Someone's crying Lord, Kum ba yah.
3. Someone's singing Lord, Kum ba yah.

My Bonnie Lies Over the Ocean

H.J. Fulmer

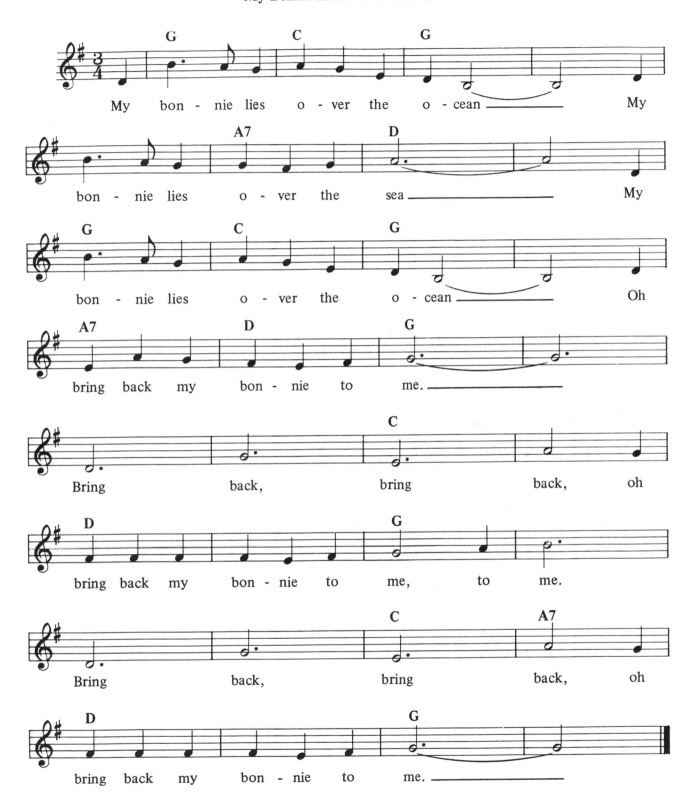

A Poor Wayfaring Stranger

Anon.

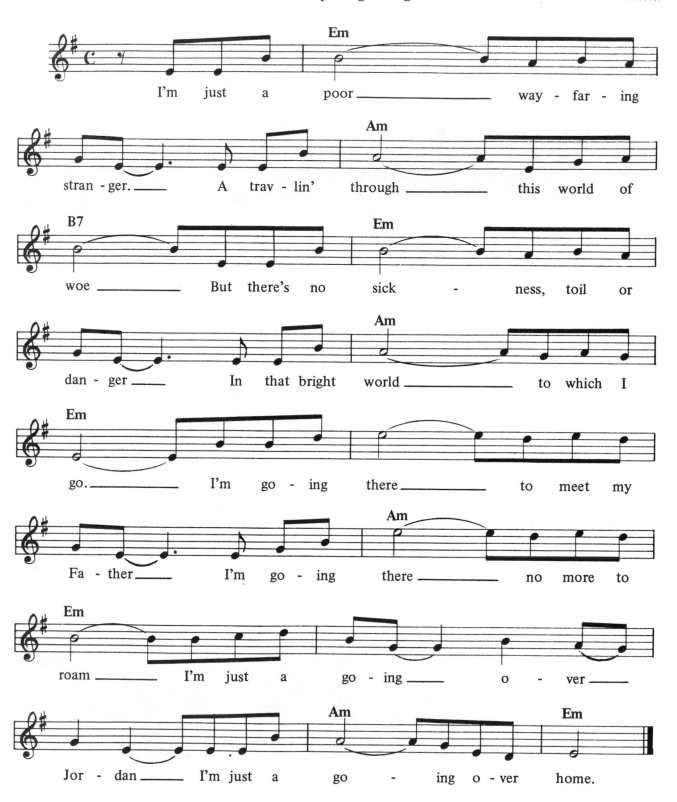

I'm just a poor _____ way - far - ing

stran - ger. ___ A trav - lin' through ____ this world of

woe ____ But there's no sick - ness, toil or

dan - ger ___ In that bright world ____ to which I

go. ____ I'm go - ing there ____ to meet my

Fa - ther ___ I'm go - ing there ____ no more to

roam ____ I'm just a go - ing ___ o - ver ___

Jor - dan ___ I'm just a go - ing o - ver home.

Shenandoah

Anon.

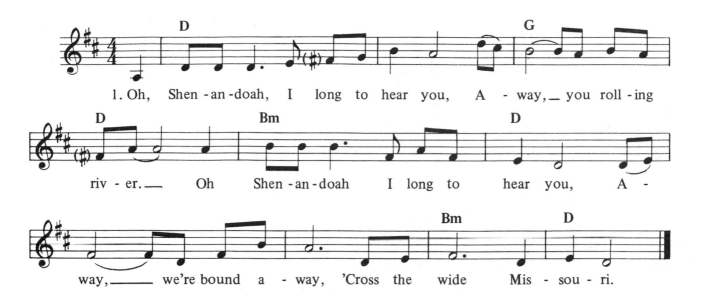

1. Oh, Shen -an -doah, I long to hear you, A - way,— you roll -ing riv - er.— Oh Shen -an -doah I long to hear you, A -way,—— we're bound a - way, 'Cross the wide Mis - sou - ri.

ADDITIONAL VERSES:

2. The white man loved the Indian maiden,
 Away, you rolling river
 With notions his canoe was laden,
 Away, we're bound away,
 'Cross the wide Missouri.

3. O Shenandoah, I love your daughter,
 Away, you rolling river
 I'll take her 'cross the rolling water,
 Away, we're bound away
 'Cross the wide Missouri.

4. O, Shenandoah, I'm bound to leave you,
 Away, you rolling river,
 O, Shenandoah, I'll not deceive you,
 Away, we're bound away,
 'Cross the wide Missouri.

Oh, Sinner Man

Spiritual

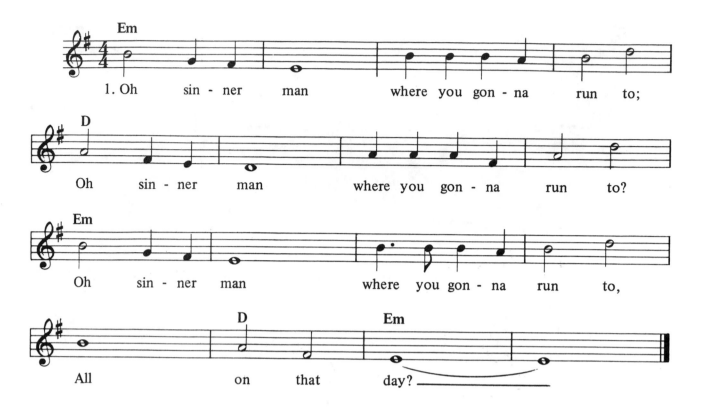

1. Oh sin-ner man where you gon-na run to;

Oh sin-ner man where you gon-na run to?

Oh sin-ner man where you gon-na run to,

All on that day? _____

ADDITIONAL VERSES:

2. Run to the rock, the rock was a melting (3 times)
 All on that day.

3. Run to the sea, the sea was a boiling, (3 times)
 All on that day.

4. Run to the moon, the moon was a bleeding, (3 times)
 All on that day.

5. Run to the Lord, Lord won't you hide me? (3 times)
 All on that day.

6. Run to the devil, devil was a-waiting, (3 times)
 All on that day.

7. Oh sinner man, you ought a been a praying (3 times)
 All on that day.

Cripple Creek　　　　　　　　　　　　　　　　*Trad.*

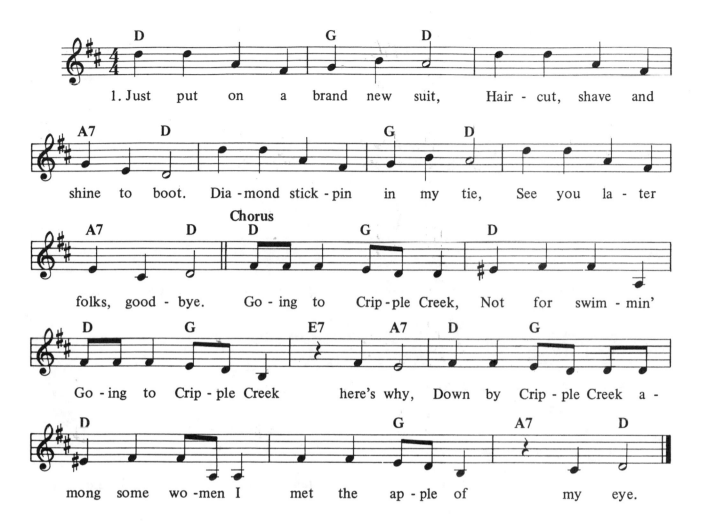

1. Just put on a brand new suit, Hair - cut, shave and shine to boot. Dia - mond stick - pin in my tie, See you la - ter folks, good - bye.

Chorus

Go - ing to Crip - ple Creek, Not for swim - min' Go - ing to Crip - ple Creek here's why, Down by Crip - ple Creek a - mong some wo - men I met the ap - ple of my eye.

ADDITIONAL VERSES:

2. One was fat and one was lean,
One was somewhere in between,
Took one look and I got weak,
By the banks of Cripple Creek.

CHORUS

3. Man! That gal has me bewitched,
All dressed up for gettin' hitched
Gonna meet her, cheek to cheek,
In the church by Cripple Creek.

Home on the Range

Trad. Cowboy Song

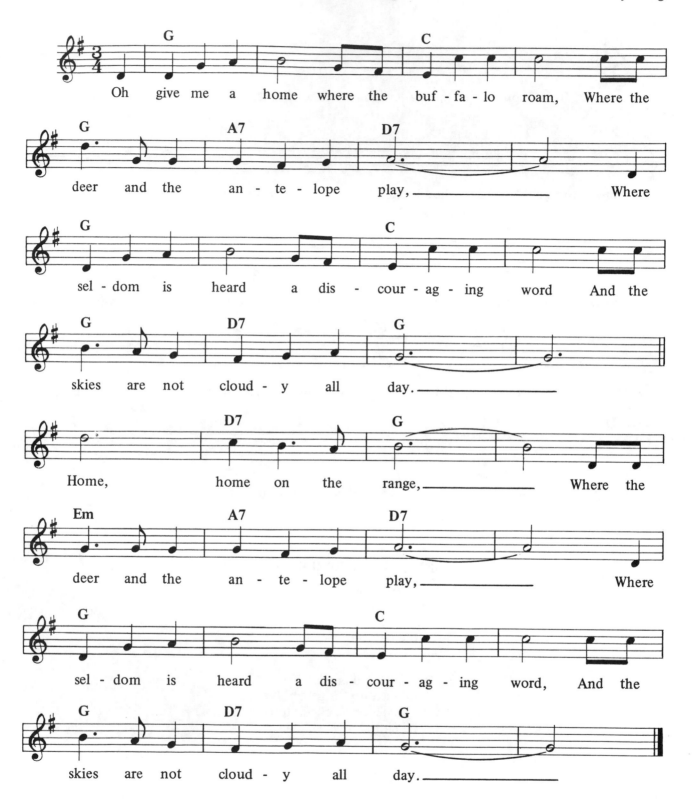

Oh give me a home where the buf - fa - lo roam, Where the

deer and the an - te - lope play, _____ Where

sel - dom is heard a dis - cour - ag - ing word And the

skies are not cloud - y all day. _____

Home, home on the range, _____ Where the

deer and the an - te - lope play, _____ Where

sel - dom is heard a dis - cour - ag - ing word, And the

skies are not cloud - y all day. _____

John Henry *Unknown*

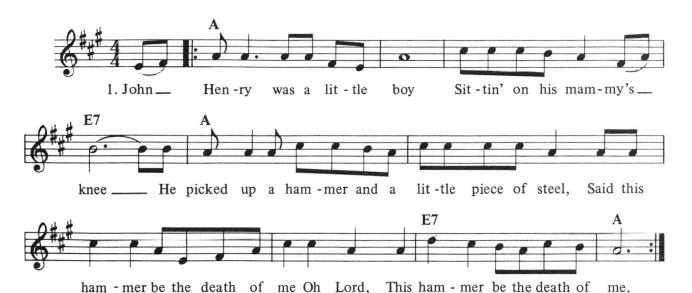

1. John— Hen-ry was a lit-tle boy Sit-tin' on his mam-my's—
knee— He picked up a ham-mer and a lit-tle piece of steel, Said this
ham-mer be the death of me Oh Lord, This ham-mer be the death of me.

ADDITIONAL VERSES:

2. Now the captain said to John Henry
 Gonna bring my steam drill 'round
 Watch that smoke roll out its stack
 While it drives that cold steel down Lord, Lord
 While it drives that cold steel down.

3. Now John Henry said to the captain
 A man ain't nothin' but a man
 Before I let that steam hammer beat me down
 I'll die with a hammer in my hand Lord, Lord
 I'll die with a hammer in my hand.

4. John Henry went on the mountain
 He looked on the other side
 He looked at the sky with tears in his eyes
 And he laid down his hammer and he died Lord, Lord
 He laid down his hammer and he died.

5. Now they buried John in the graveyard
 Six feet under the sand
 And every train that goes a chuggin' on by
 Says yonder lies a steel drivin' man Lord, Lord
 Yonder lies a steel drivin' man.

Scarborough Fair *Old English Song*

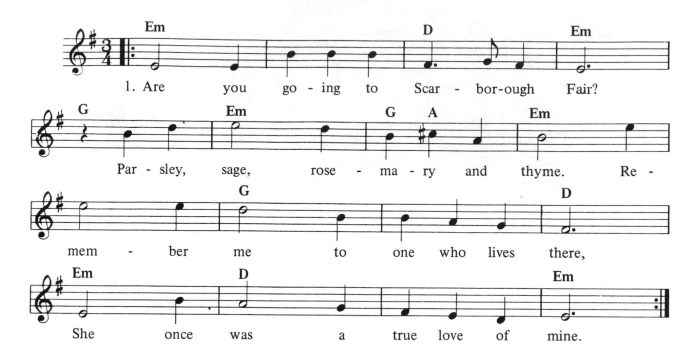

1. Are you go - ing to Scar - bor-ough Fair?
Par - sley, sage, rose - ma - ry and thyme. Re -
mem - ber me to one who lives there,
She once was a true love of mine.

ADDITIONAL VERSES:

2. Tell her to make me a cambric shirt
 Parsley sage, rosemary and thyme
 Without no seams nor needlework
 Then she'll be a true love of mine.

3. Tell her to find me an acre of land
 Parsley sage, rosemary and thyme
 Between the salt water and the sea strands
 Then she'll be a true love of mine.

9

CHORD REFERENCE SHEETS

Major Chords

 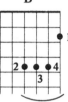 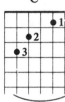 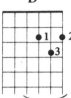

A B♭ B C D

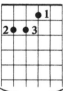 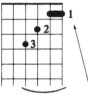 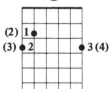

E F G

The first finger lays across two strings.

Minor Chords (m)

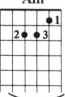 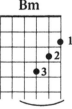 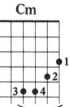 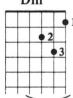 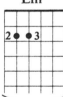

Am Bm Cm Dm Em

Fm Gm

Seventh Chords (7)

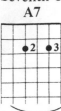
A7

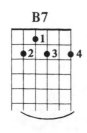
B7

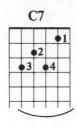
C7

D7

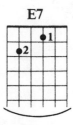
E7

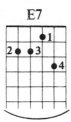
E7

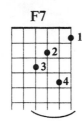
F7

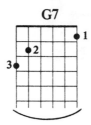
G7

Major Seventh Chords (maj.7 — Major sevenths may also be written $\overline{7}$ or Δ)

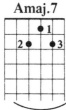
Amaj.7

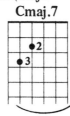
Cmaj.7

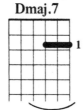
Dmaj.7

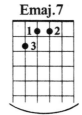
Emaj.7

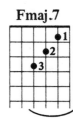
Fmaj.7

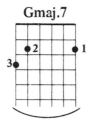
Gmaj.7

Minor Seventh Chords (m7)

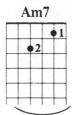
Am7

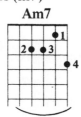
Am7

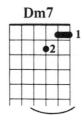
Dm7

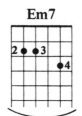
Em7

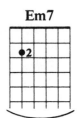
Em7

Major Sixth Chords (6)

A6
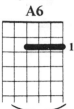

C6
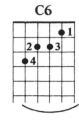

D6
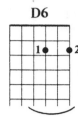

E6
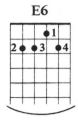

F6
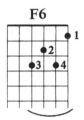

G6
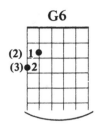

Suspended Chords (sus.)

Asus.
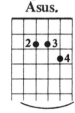

Csus.
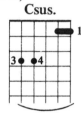

Dsus.
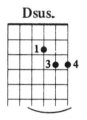

Esus.
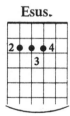

Fsus.
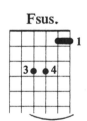

Gsus.
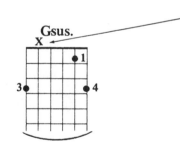

An x above a string indicates that string is to be muted (or deadened). This is done by tilting a finger which is pushing on a lower string (in this case the 3rd finger) and lightly touching the string to be muted. When the chord is strummed, the muted string should not be heard.

Seventh Suspended Chords (7sus.)

A7sus.
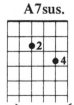

C7sus.
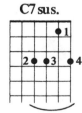

D7sus.
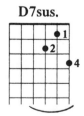

E7sus.
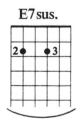

G7sus.
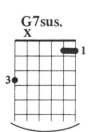

Add Nine Chords (add9)

Aadd9	Cadd9	Dadd9	Eadd9	Gadd9

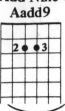 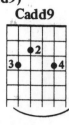

Diminished Seventh Chords (dim. or o)
Cdim., D♯ dim., Adim., F♯ o **C♯ dim., Edim., B♭ dim., Go**

 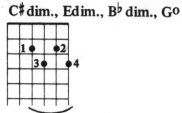

The diminished seventh chord can have four letter names for the same pattern. Every finger is on a note which names the chord.

Augmented Chords (aug. or +)
Faug., C♯ aug., A+

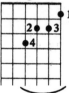

The augmented chord can have three letter names for the same pattern. Here again, each finger is on a note which names the chord.